Serenity

宁静 **FIREFLY CLASS 03-K64** ™

President and Publisher **MIKE RICHARDSON**

Editor **FREDDYE MILLER**

Assistant Editor **KEVIN BURKHALTER**

Designer **SARAH TERRY**

Digital Art Technician **CHRISTIANNE GOUDREAU**

Neil Hankerson Executive Vice President **Tom Weddle** Chief Financial Officer **Randy Stradley** Vice President of Publishing **Matt Parkinson** Vice President of Marketing **David Scroggy** Vice President of Product Development **Dale LaFountain** Vice President of Information Technology **Cara Niece** Vice President of Production and Scheduling **Nick McWhorter** Vice President of Media Licensing **Mark Bernardi** Vice President of Book Trade and Digital Sales **Ken Lizzi** General Counsel **Dave Marshall** Editor in Chief **Davey Estrada** Editorial Director **Scott Allie** Executive Senior Editor **Chris Warner** Senior Books Editor **Cary Grazzini** Director of Specialty Projects **Lia Ribacchi** Art Director **Vanessa Todd** Director of Print Purchasing **Matt Dryer** Director of Digital Art and Prepress **Michael Gombos** Director of International Publishing and Licensing

Special thanks to Nicole Spiegel and Carol Roeder at Twentieth Century Fox.

SERENITY: FIREFLY CLASS 03-K64—EVERYTHING'S SHINY ADULT COLORING BOOK

Published by Dark Horse Books
A division of Dark Horse Comics, Inc.
10956 SE Main Street, Milwaukie, OR 97222

DarkHorse.com

To find a comics shop in your area, call the Comic Shop Locator Service toll-free at (888) 266-4226.
International Licensing: (503) 905-2377

First edition: October 2017 | ISBN 978-1-50670-459-3

1 3 5 7 9 10 8 6 4 2
Printed in the United States of America

ADULT COLORING BOOK

With Illustrations by

STEPHEN BYRNE

PABLO CHURIN

WILL CONRAD

EDUARDO FRANCISCO

JUAN FRIGERI

GEORGES JEANTY

TAYLOR ROSE

DARK HORSE BOOKS

"I got people with me, people who trust each other, who do for each other and ain't always looking for the advantage."

—Mal, "Our Mrs. Reynolds," Episode 6

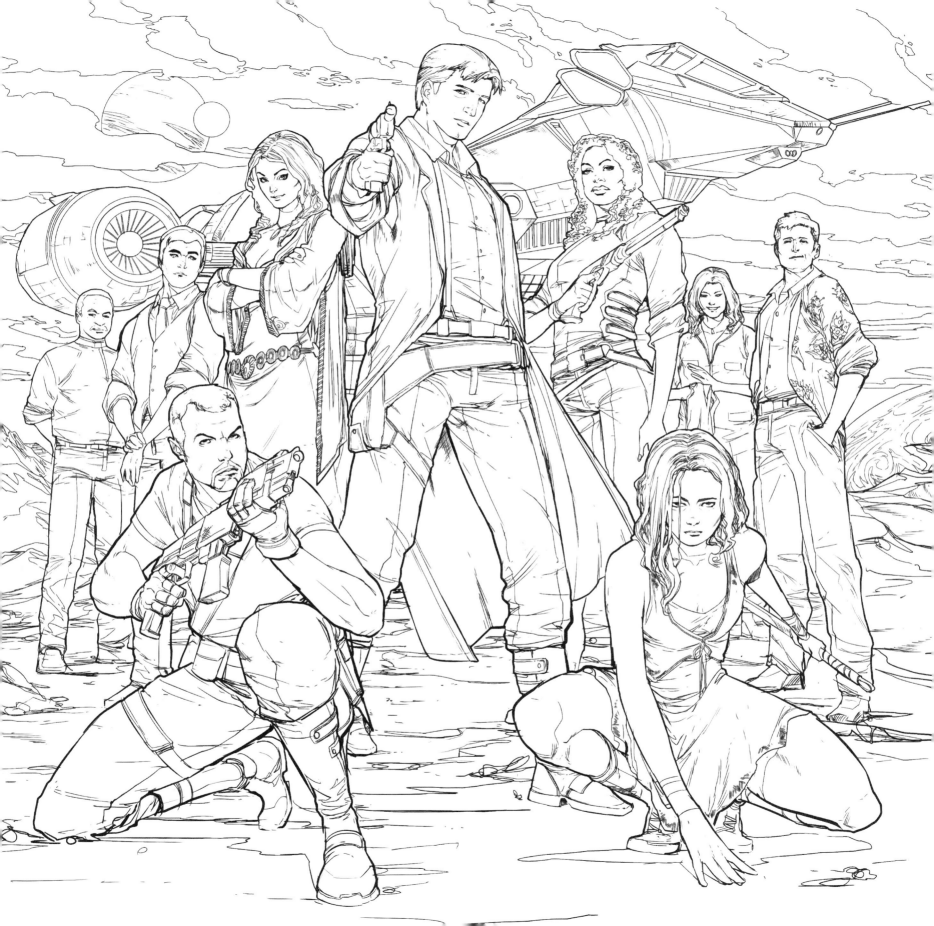

Kaylee: *You're gonna come with us.*

Book: *Excuse me?*

Kaylee: *You like ships. You don't seem to be lookin' at the destinations. What you care about is the ships, and mine's the nicest.*

Book: *She don't look like much.*

Kaylee: *Oh, she'll fool ya. You ever sailed in a Firefly?*
—"Serenity," Episode 1

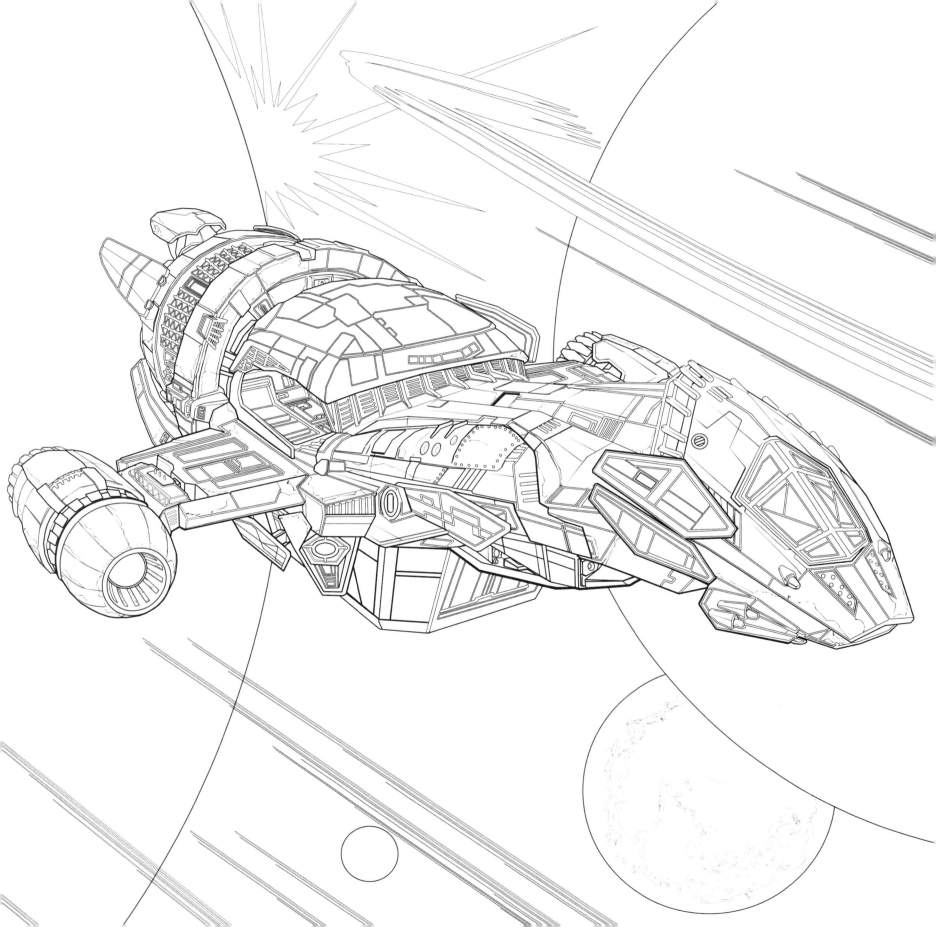

Book: *So, how do you think it's going?*

Inara: *The caper? Mal knows what he's doing.*

Book: *How long have you known him?*

Inara: *I've been on this ship eight months now. I'm not sure I'll ever actually know the Captain.*

Book: *I'm surprised a respectable Companion would sail with this crew.*

Inara: *It's not always this sort of work. They take the jobs they can get, even legitimate ones. The further you get away from the Central Planets, the harder things are, so this is part of it.*

Book: *I wish I could help. I mean, I don't wanna . . . not help help, not with the thieving, but . . . I do feel awfully useless.*

Inara: *You could always pray they make it back safely.*

Book: *I don't think the Captain would much like me praying for him.*

Inara: *Don't tell him. I never do.*

—"The Train Job," Episode 2

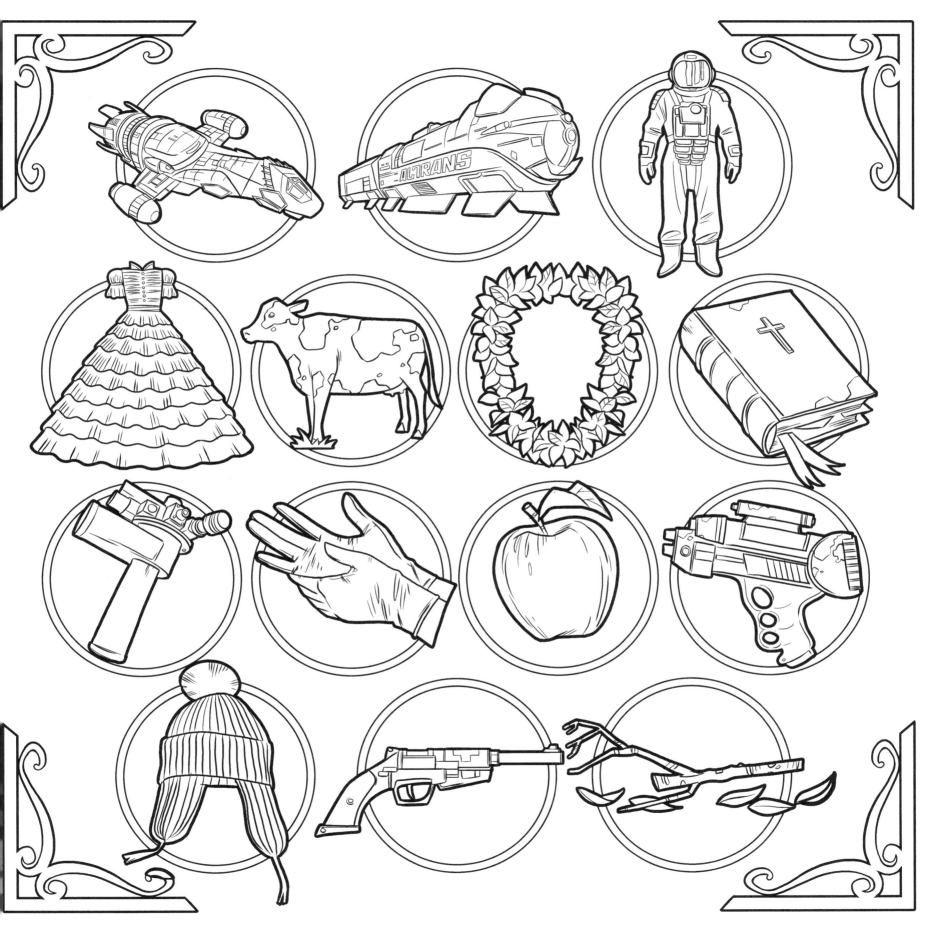

Zoe: *Alliance catches us with government goods, we'll lose the ship.*

Mal: *That's never gonna happen.*

Zoe: *Sir, we could just dump the cargo.*

Jayne: *No ruttin' way. We ain't had a job in weeks. I didn't sign on with this crew to take in the sights. We need coin.*

Mal: *Jayne, your mouth is talking. You might wanna look to that.*

Jayne: *Oh, I'm ready to stop talkin'—*

Mal: *You're right, though. The last two jobs we had were weak tea. We got nothing saved, takin' on passengers won't help near enough . . . We don't get paid for this cargo, we don't have enough money to fuel the ship, let alone keep her in repair. She'll be dead in the water.*

—"Serenity," Episode 1

Simon: *I'm trying to put this as delicately as I can . . . How do I know you won't kill me in my sleep?*

Mal: *You don't know me, son, so let me explain this to you once: If I ever kill you, you'll be awake, you'll be facing me, and you'll be armed.*

Simon: *Are you always this sentimental?*

Mal: *I had a good day.*

Simon: *You had the Alliance on you . . . criminals and savages . . . Half the people on the ship have been shot or wounded, including yourself . . . And you're harboring known fugitives.*

Mal: *We're still flying.*

Simon: *That's not much.*

Mal: *It's enough.*

—"Serenity," Episode 1

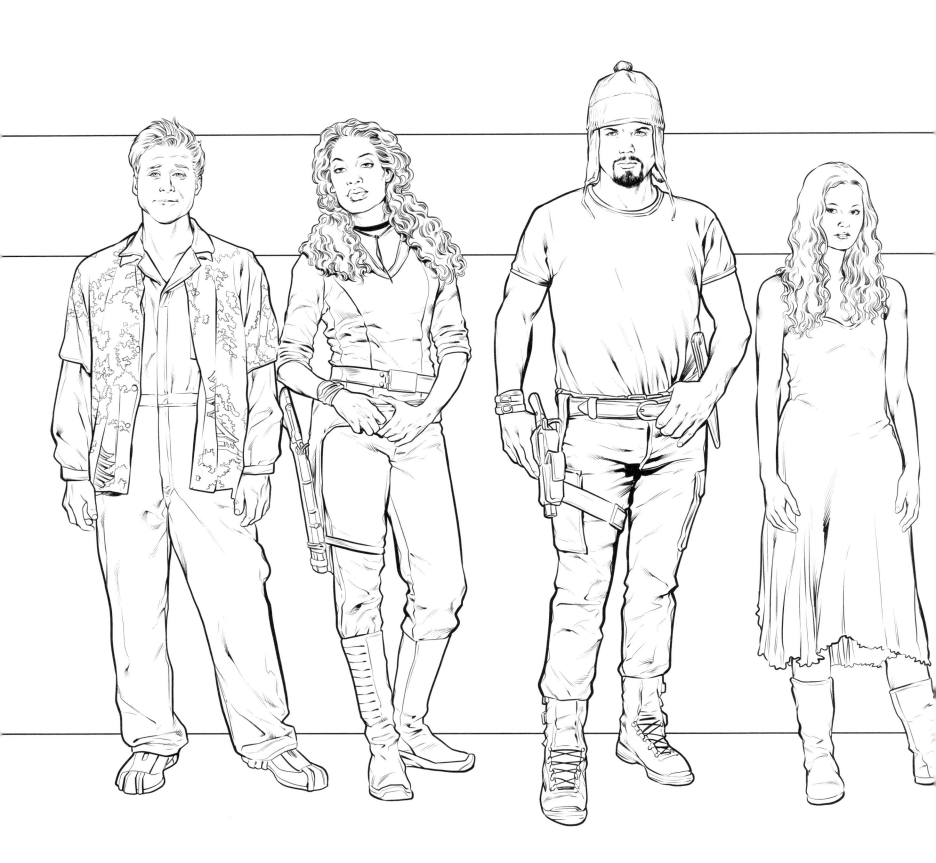

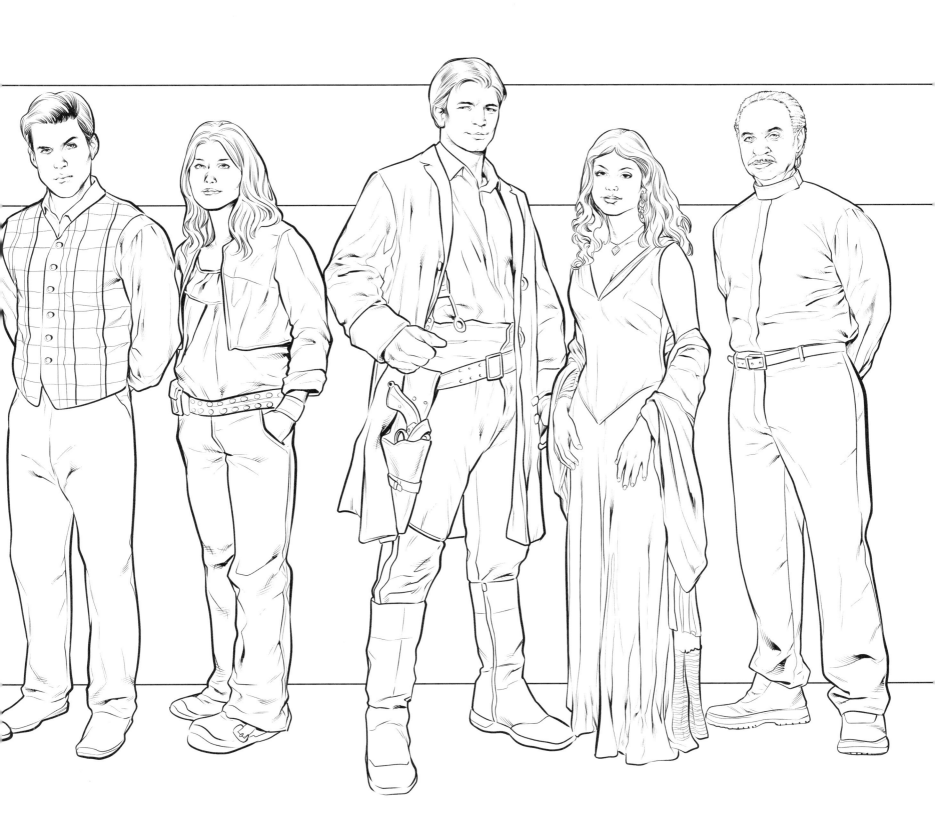

Mal: *This shouldn't take long. Put us down for departure in about three hours. Grab any supplies we're low on. Fuel her up.*

Kaylee: *I'd sure love to find a brand new compression coil for the steamer.*

Mal: *And I'd like to be king of all Londinum and wear a shiny hat. Just get us some passengers. Them as can pay, all right?*

Kaylee: *Compression coil busts, we're drifting . . .*

Mal: *Best not bust, then.*

—"Serenity," Episode 1

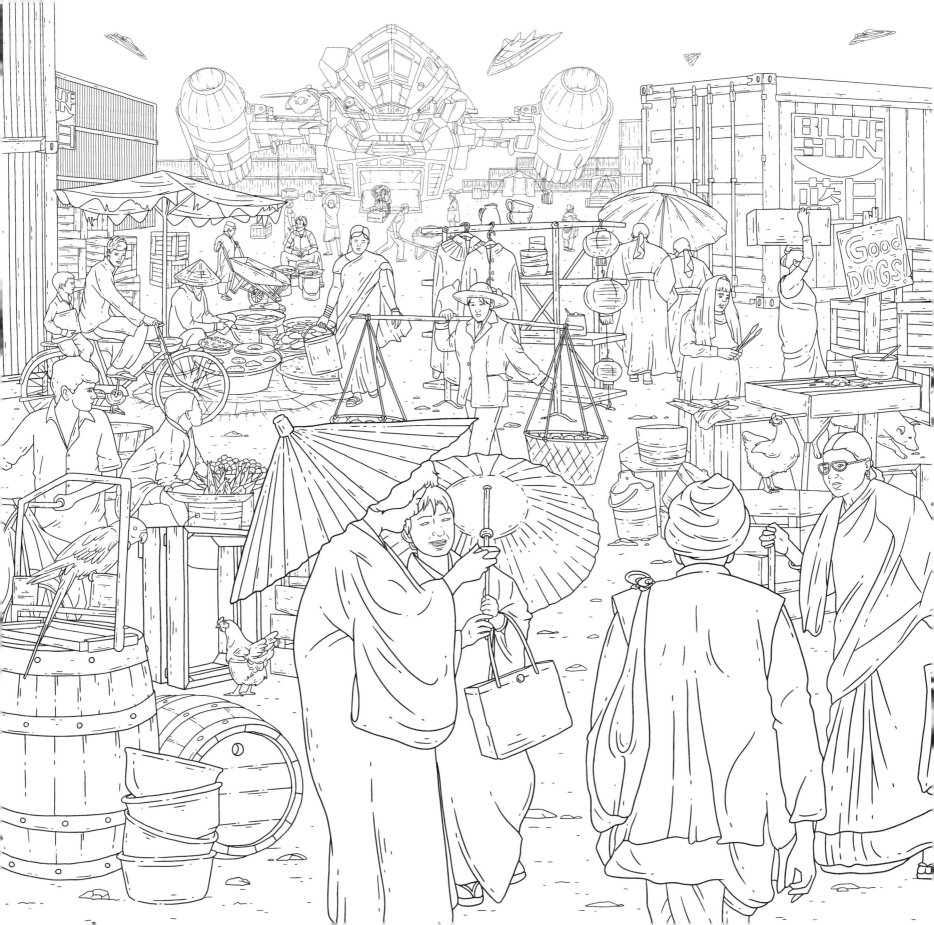

Mal: *Well, you were right about this being a bad idea.*

Zoe: *Thanks for sayin', sir.*

Patience: *Mal, don't you take another step—*

Mal: *Now I did a job. I got nothing but trouble since I did it—not to mention more than a few unkind words as regard to my character—so let me make this abundantly clear: I do the job. And then I get paid.*
 —"Serenity," Episode 1

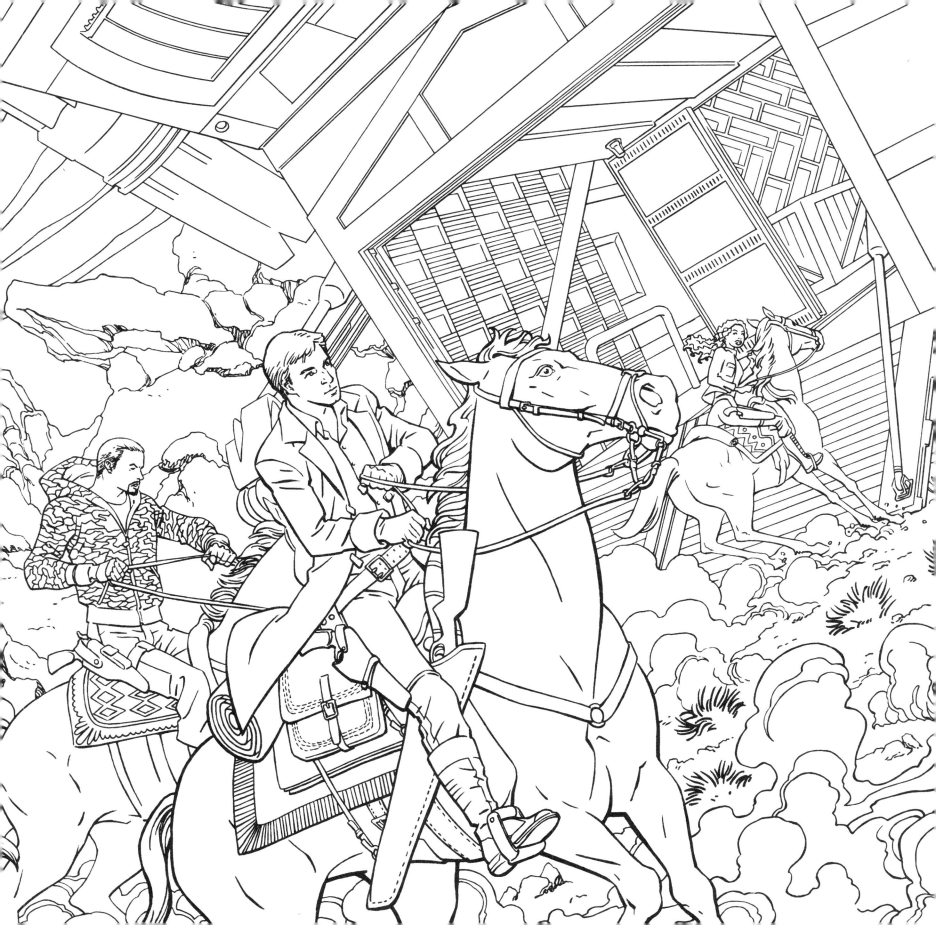

Mal: *We're passing another ship. Looks to be Reavers. From the size, probably a raiding party. Could be they're headed somewhere particular, could be they've already hit someone and they're full up. So everyone stay calm. We try to run, they'll have to chase us. It's their way. We're holding course. We should be passing 'em in a minute, so we'll see what they do. Zoe, you come on up to the bridge.*

Simon: *Wait—I-I don't understand.*

Zoe: *You've never heard of Reavers?*

Simon: *Well . . . campfire stories . . . Men gone savage on the edge of space, killing, and . . .*

Zoe: *They're not stories.*

Simon: *What happens if they board us?*

Zoe: *If they take the ship, they'll rape us to death, eat our flesh and sew our skins into their clothing, and if we're very very lucky, they'll do it in that order.*

—**"Serenity,"** Episode 1

Jayne: *Mal! It's Wash! We got a ship coming in. They followed us. The gorram Reavers followed us!*

Wash: *Reavers! Reavers incoming and headed straight for us. We are in the air in one minute . . . I guess they got hungry again.*

Wash: *Gonna need a little push here.*

Kaylee: *You want me to go for full burn?*

Wash: *Not just yet, but set it up.*

Kaylee: *We're ready for full burn on your mark.*

Zoe: *Full burn in atmo? That won't cause a blowback? Burn us out?*

Mal: *Even if it doesn't, they can push just as hard, keep right on us. Wash, you gotta give me an Ivan.*

Wash: *I'll see what I can do. Kaylee, how would you feel about pulling a Crazy Ivan?*

Kaylee: *Always wanted to try one.*

—"Serenity," Episode 1

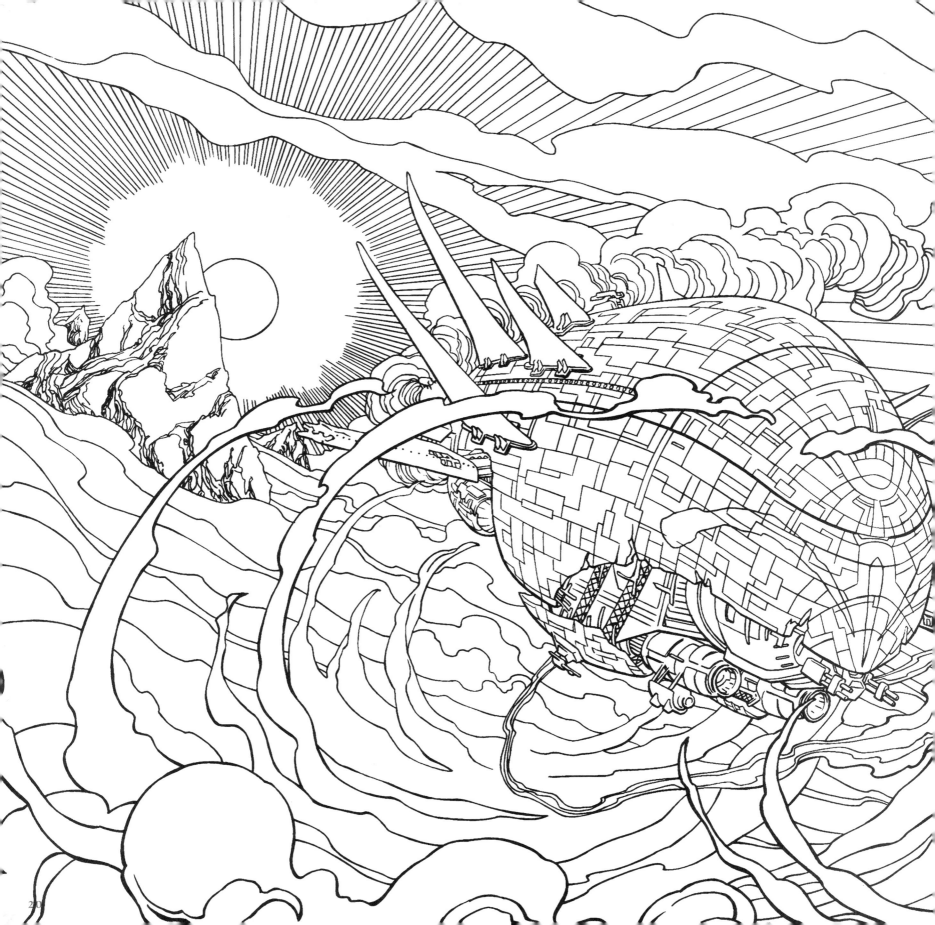

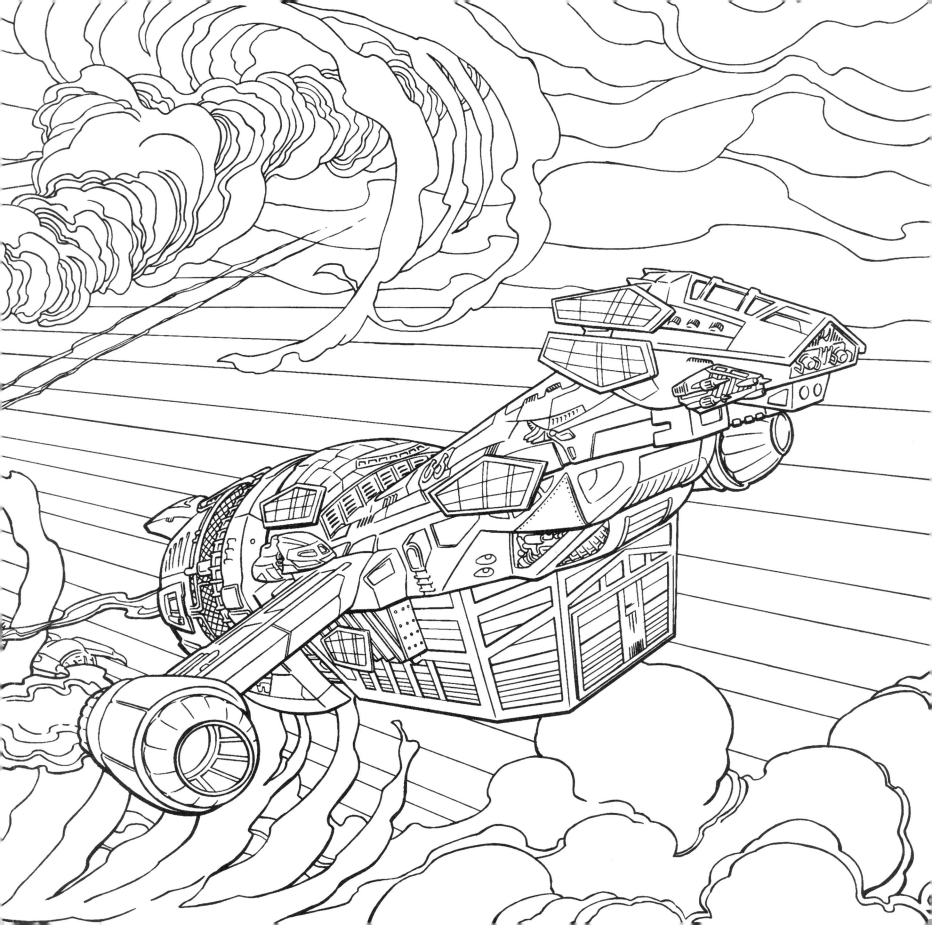

Lund: *Hey, you gonna drink t' the Alliance wi' me? Six years today, the Alliance sent the Browncoats running, pissing their pants . . .Y'know, your coat is kinda a brownish color.*

Mal: *It was on sale.*

Lund: *You didn't toast? Y'know, I'm thinkin' you one of them Independents.*

Mal: *And I'm thinkin' you weren't burdened with an overabundance of schooling. So why don't we just ignore each other, 'til we go away?*

Lund: *The Independents were a bunch of cowardly inbred pisspots. Shoulda been killed off of every world spinnin'.*

Mal: *Say that to my face.*

Lund: *I said, you're a coward, and a pisspot. Now what are you gonna do about it?*
—"The Train Job," Episode 2

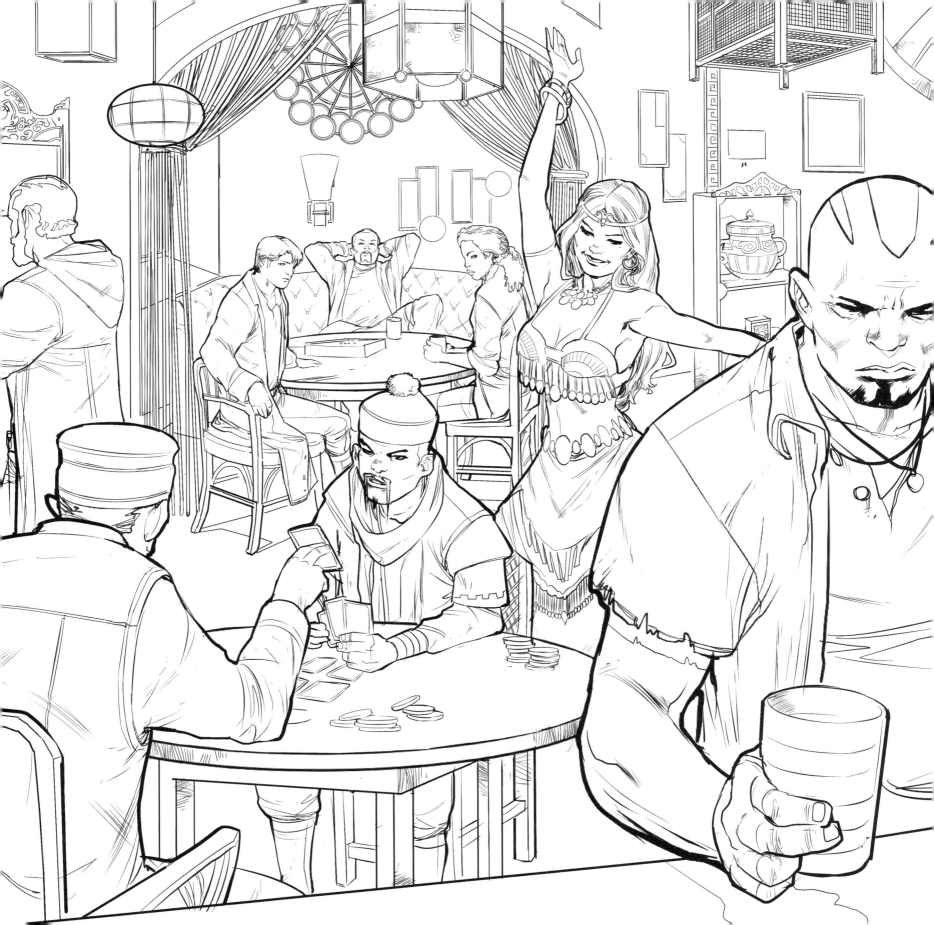

Mal: *There's, umm . . . We haven't gotten a location yet. We'll be landing on the Skyplex in a bit. Run by a fellow called Niska.*

Inara: *Never heard of him.*

Mal: *Well I have. While we're there, you'll stay confined to the ship.*

Inara: *Is the petty criminal perchance ashamed to be riding with a Companion?*

Mal: *This guy has a very unlovely rep. He's got work for me, fine. But I don't . . . I'm not sure you'd be safe.*

Inara: *Mal, if you're being a gentleman, I may die of shock.*

<div align="right">

—"The Train Job," Episode 2

</div>

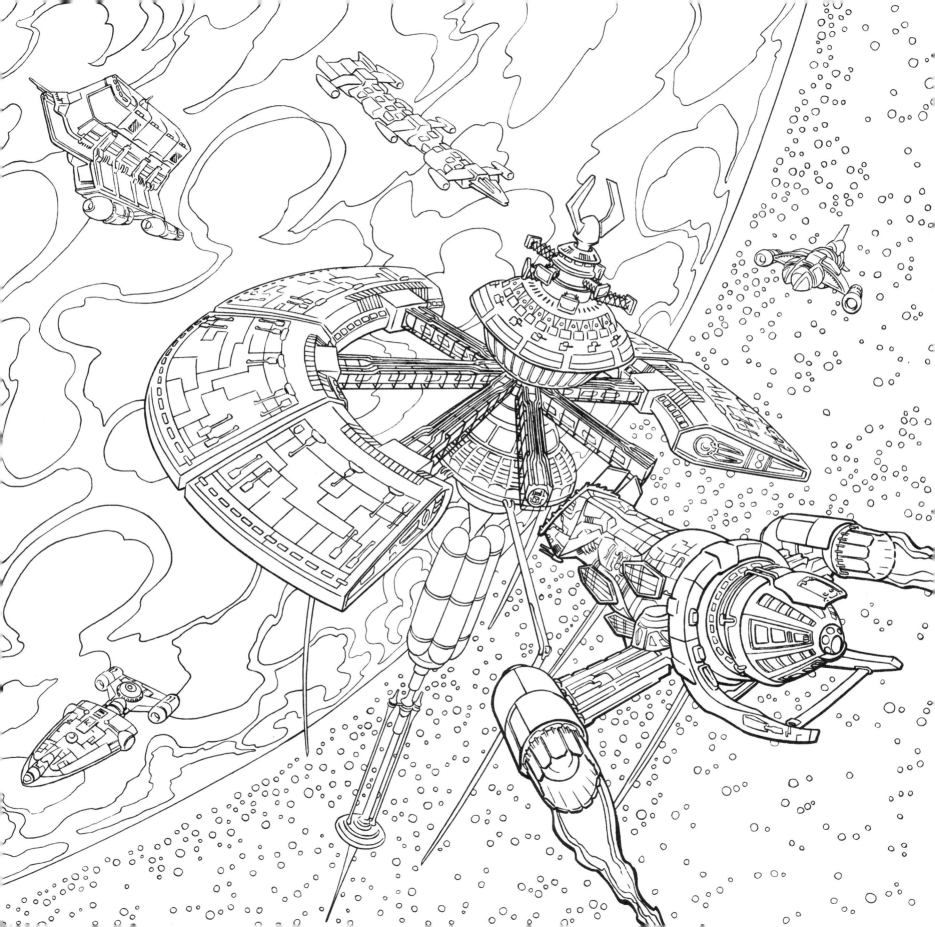

Zoe: *Now we have a boatful of citizens right on top of our . . . stolen cargo. That's a fun mix.*

Mal: *Ain't no way in the 'verse they could find that compartment, even . . . even if they were lookin' for it.*

Zoe: *Why not?*

Mal: *'Cause . . . ?*

Zoe: *Oh yeah, this is gonna go great.*

Mal: *If anyone gets nosy, just, you know . . . shoot 'em.*

Zoe: *Shoot 'em?*

Mal: *Politely.*

—"Serenity," Episode 1

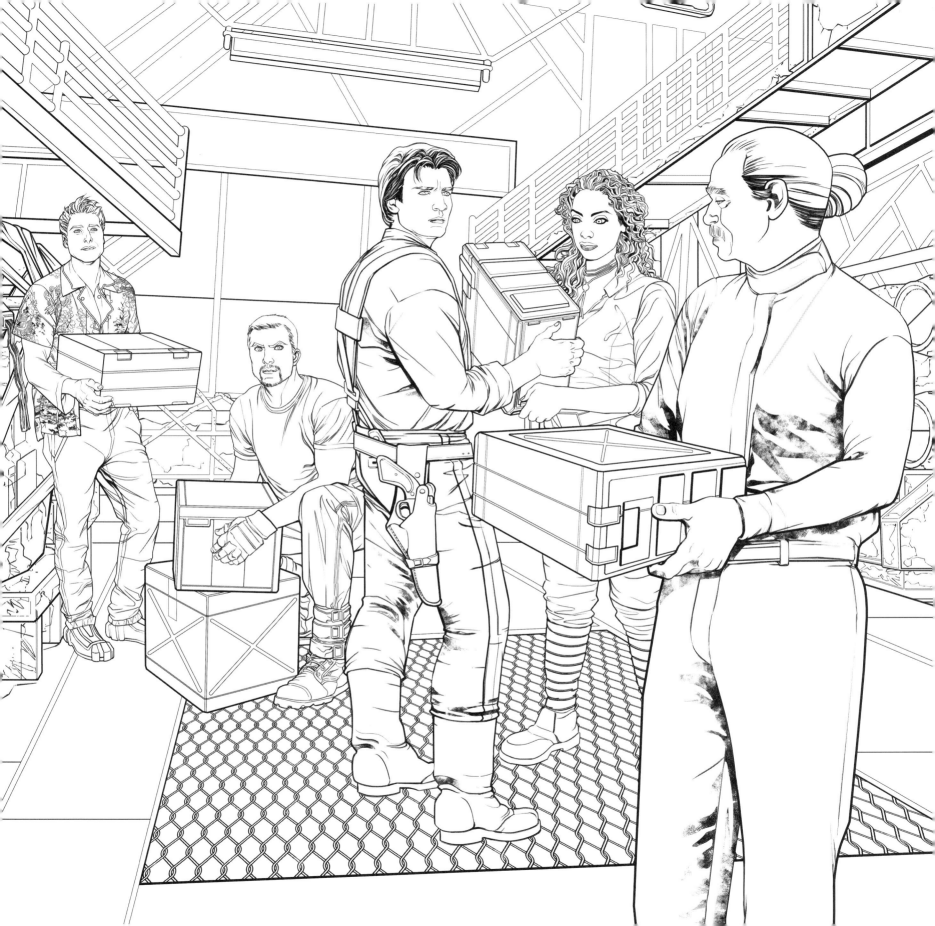

Mal: *This is exactly what I didn't want. I wanted simple. I wanted in-and-out. I wanted easy money.*

Zoe: *Things always get a little more complicated, don't they, sir?*

Mal: *Just once I'd like things to go according to the gorram plan.*

Wash: *Uh, guys, you might wanna hurry.*

Mal: *Oh, is there a problem?*

—"Ariel," Episode 9

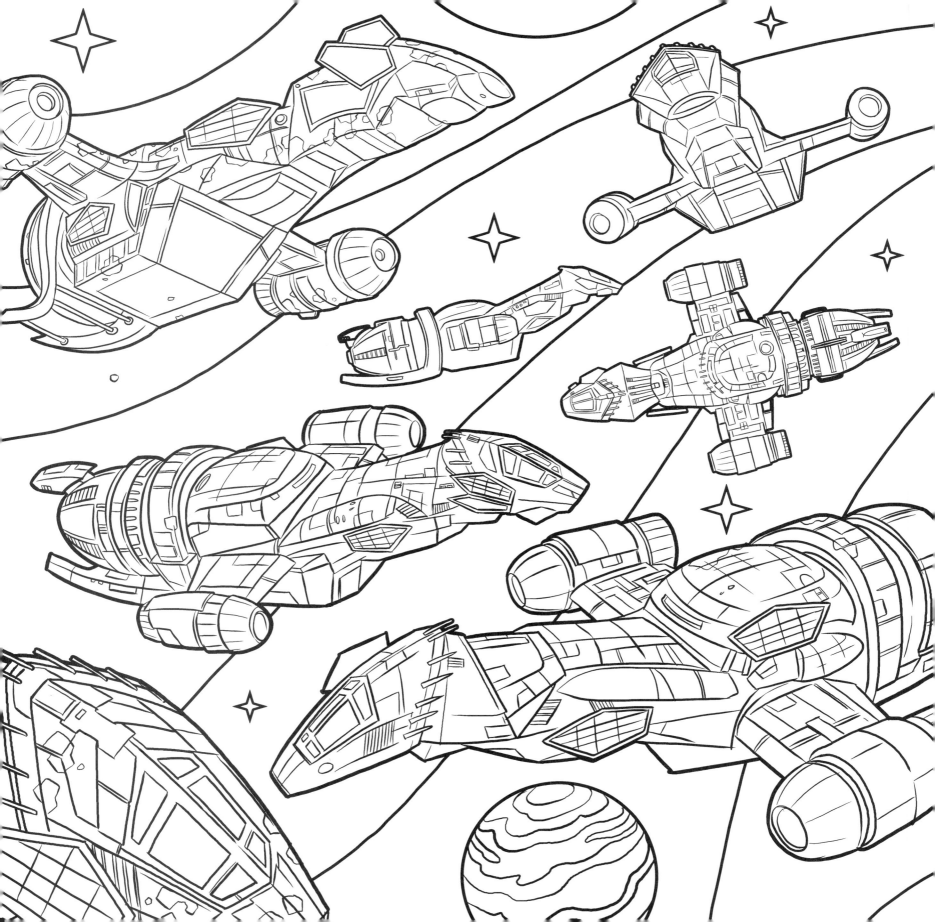

Mal: *I got no notion to argue this. In about two minutes time this boat's going to be crawling with Alliance.*

Simon: *No. We've got to run.*

Mal: *Can't run. They're pulling us in.*

Simon: *If they find us they'll send River back to that place. To be tortured. I'd never see her again.*

Mal: *Stack everything here, in plain sight. Wouldn't want it to seem like we got anything to hide. It might give them Alliance boys the wrong impression.*

Wash: *Or the right one.*

Mal: *That too.*

—"Bushwhacked," Episode 3

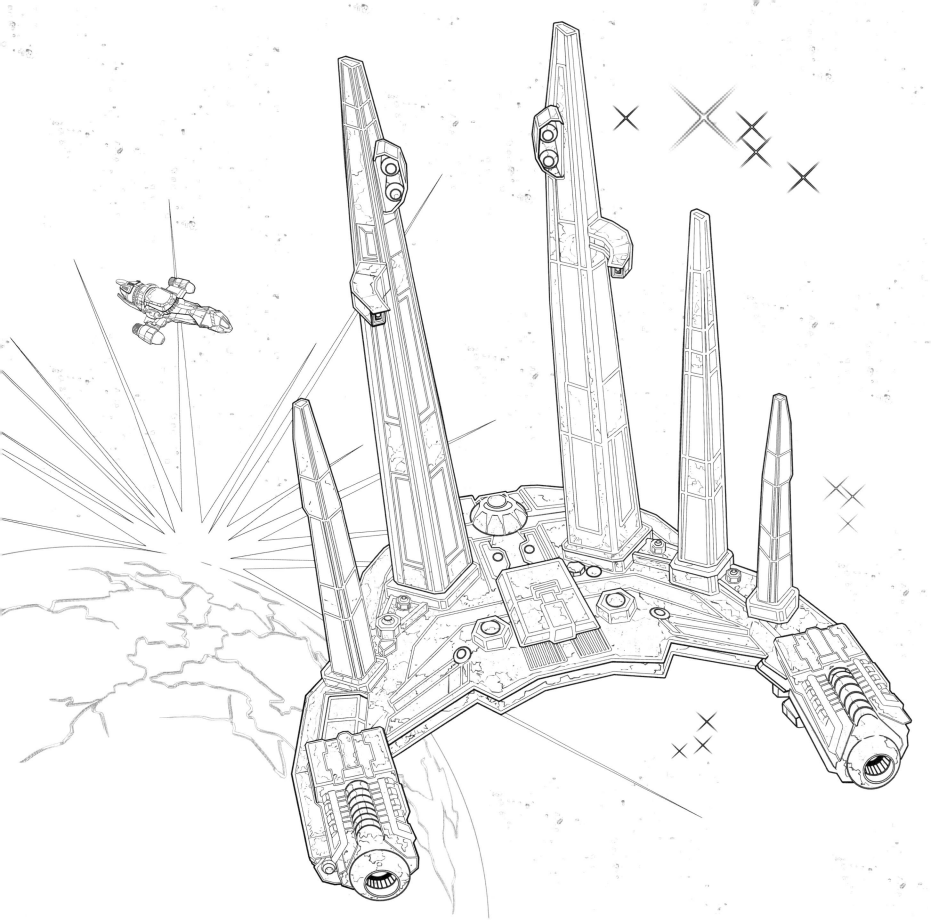

Inara: *Are you in pain?*

Mal: *Absolutely. I got stabbed, you know. Right here.*

Inara: *Eh—I saw.*

Mal: *Don't care much for fancy parties. Too rough.*

Inara: *It wasn't* entirely *a disaster.*

Mal: *I got stabbed! Right here!*

Inara: *You also lined up exciting new crime.*

—"Shindig," Episode 4

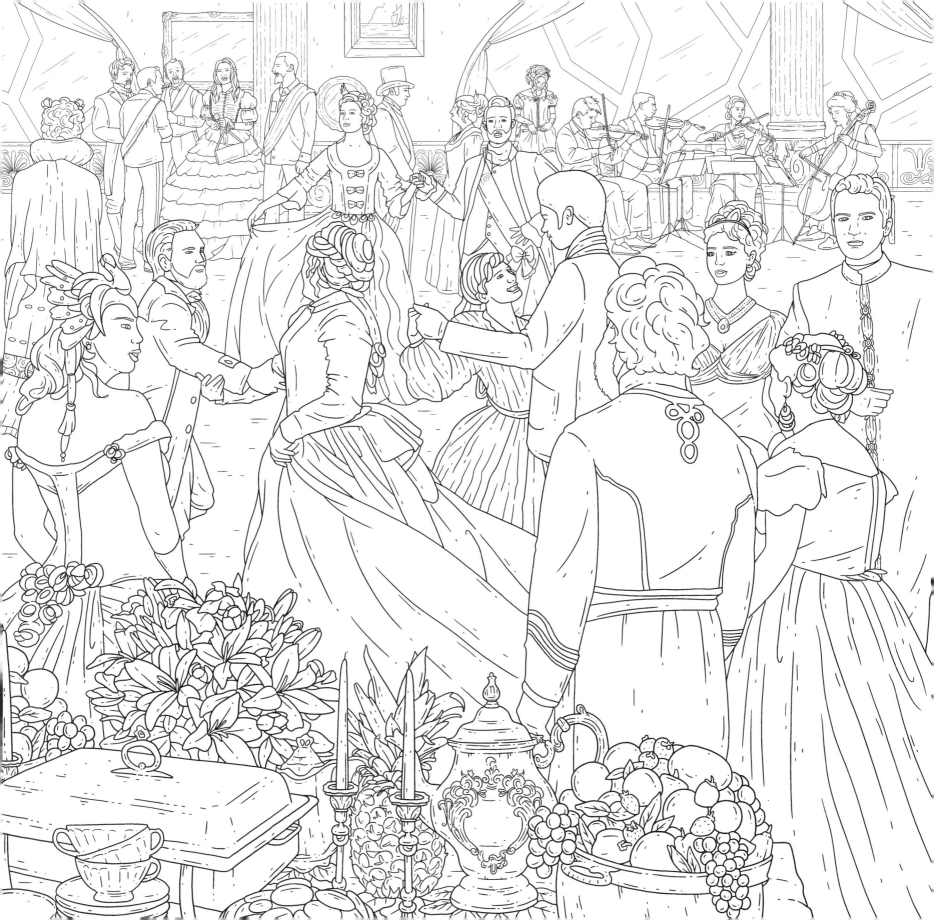

River: *Little soul, big world. Eat. Sleep. And eat. Many souls.*

Mal: *Cattle on the ship three weeks she don't go near 'em. Suddenly we're on Jiangyin and she's got a driving need to commune with the beasts?*

River: *They weren't cows inside. They were waiting to be, but they forgot. Now they see sky, and they remember what they are.*

Mal: *Is it bad that what she said made perfect sense to me?*

—"Safe," Episode 5

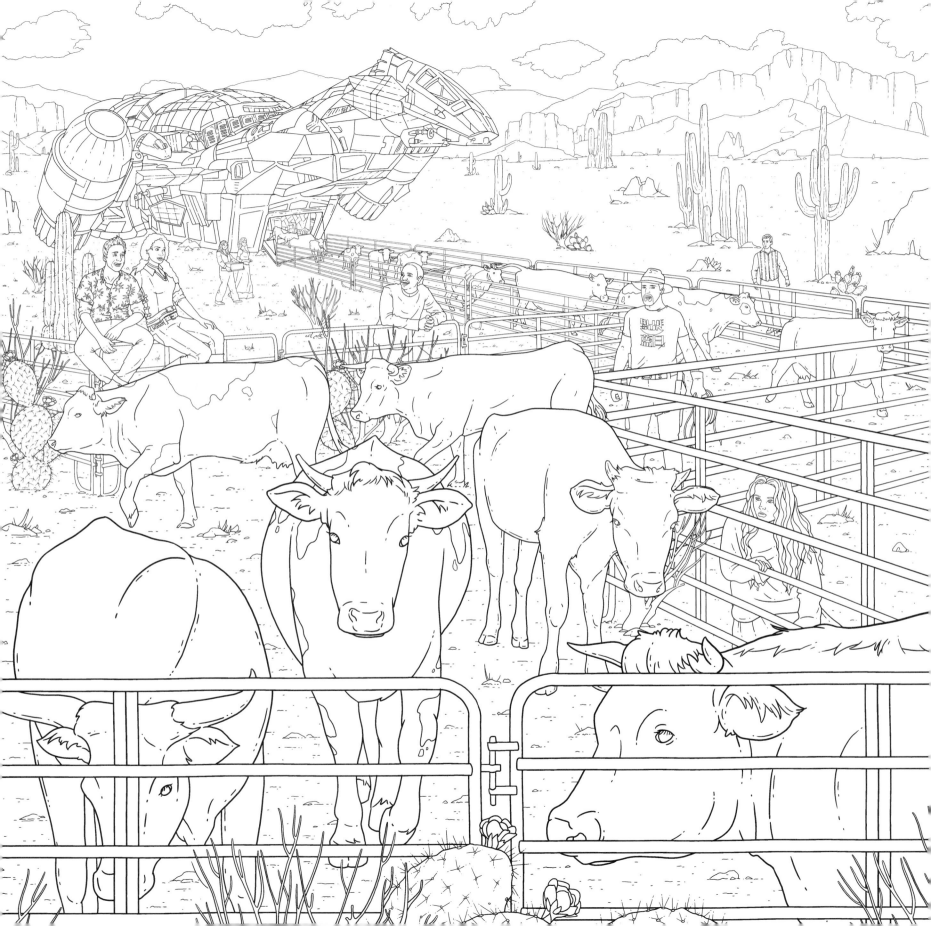

Stegosaurus: *Yes. Yes, this is a fertile land, and we will thrive. We will rule over all this land, and we will call it . . . "This Land."*

Allosaurus: *I think we should call it "Your Grave!"*

Stegosaurus: *Ah, curse your sudden but inevitable betrayal!*

Allosaurus: *Har har har! Mine is an evil laugh! Now die!*

Stegosaurus: *Oh, no, God! Oh, dear God in heaven!*
—"Serenity," Episode 1

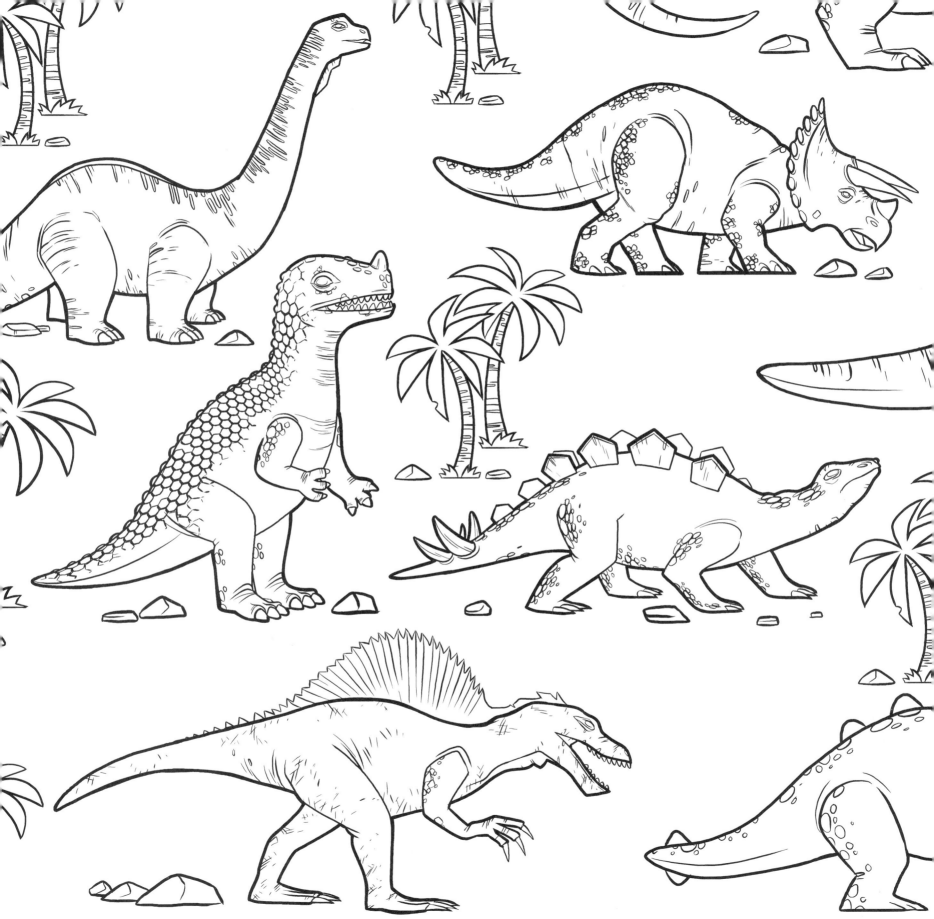

Inara: *Does it seem every supply store on every border planet has the same five rag dolls and the same wood carvings of . . . What is this? A duck?*

Kaylee: *It's a swan. I like it.*

Inara: *You do?*

Kaylee: *Looks like it was made with, you know, longing. Made by a person really* longed *to see a swan.*

Inara: *Perhaps they'd only heard of them by rough description.*

<div align="right">—"Safe," Episode 5</div>

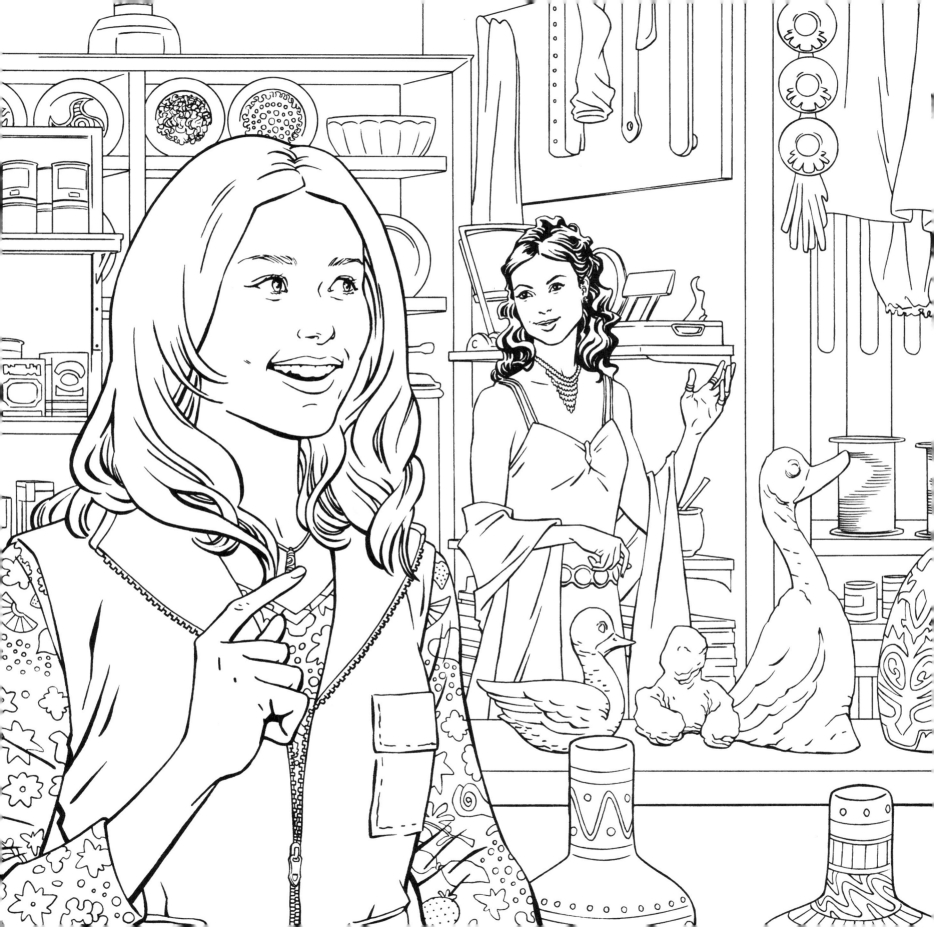

Bandit: *You gonna give us what's due us. And every damn thing else on that boat. And I think maybe you gonna give me a little one-on-one time with the missus.*

Jayne: *Oh, I think you might wanna reconsider that last part. See, I married me a* powerful *ugly creature.*

Mal: *How can you say that? How can you shame me in front of new people?*

Jayne: *If I could make you prettier I would!*

Mal: *You are* not *the man I met a year ago! . . . Now think real hard. You been bird-doggin' this township a while now. They wouldn't mind a corpse of you. Now, you can luxuriate in a nice jail cell, but if your hand touches metal, I swear by my pretty floral bonnet, I will end you.*

<div align="right">

—**"Our Mrs. Reynolds," Episode 6**

</div>

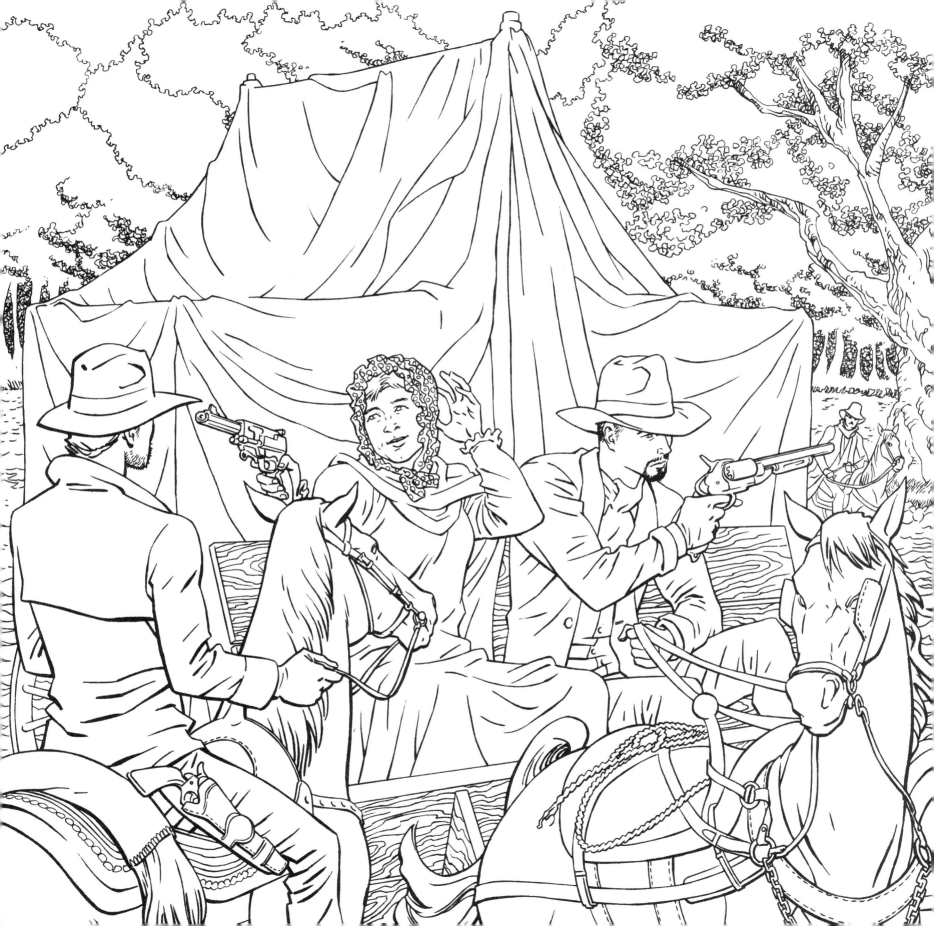

Book: *River, you don't . . . fix the Bible.*

River: *It's broken. It doesn't make sense.*

Book: *It's not about . . . making sense. It's about believing in something. And letting that belief be real enough to change your life. It's about faith. You don't fix faith, River. It fixes you.*
 —"Jaynestown," Episode 7

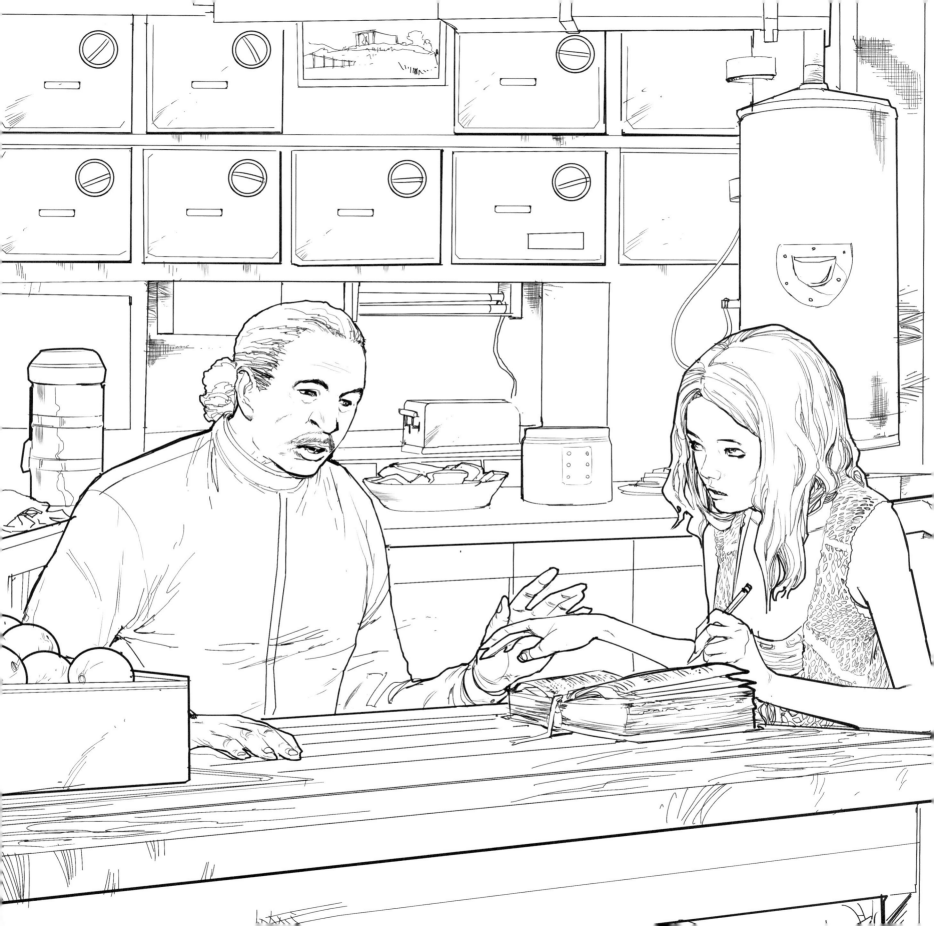

Kaylee: *Come on, admit it, it's true.*

Simon: *No, I won't, because it's not. I use swear words like anybody else.*

Kaylee: *Oh, really? See, I never heard you. So when is it you do all of this cussin'? After I go to bed, or . . .*

Simon: *I swear when it's appropriate.*

Kaylee: *Simon, the whole point of swearing is that it ain't appropriate.*

—"Jaynestown," Episode 7

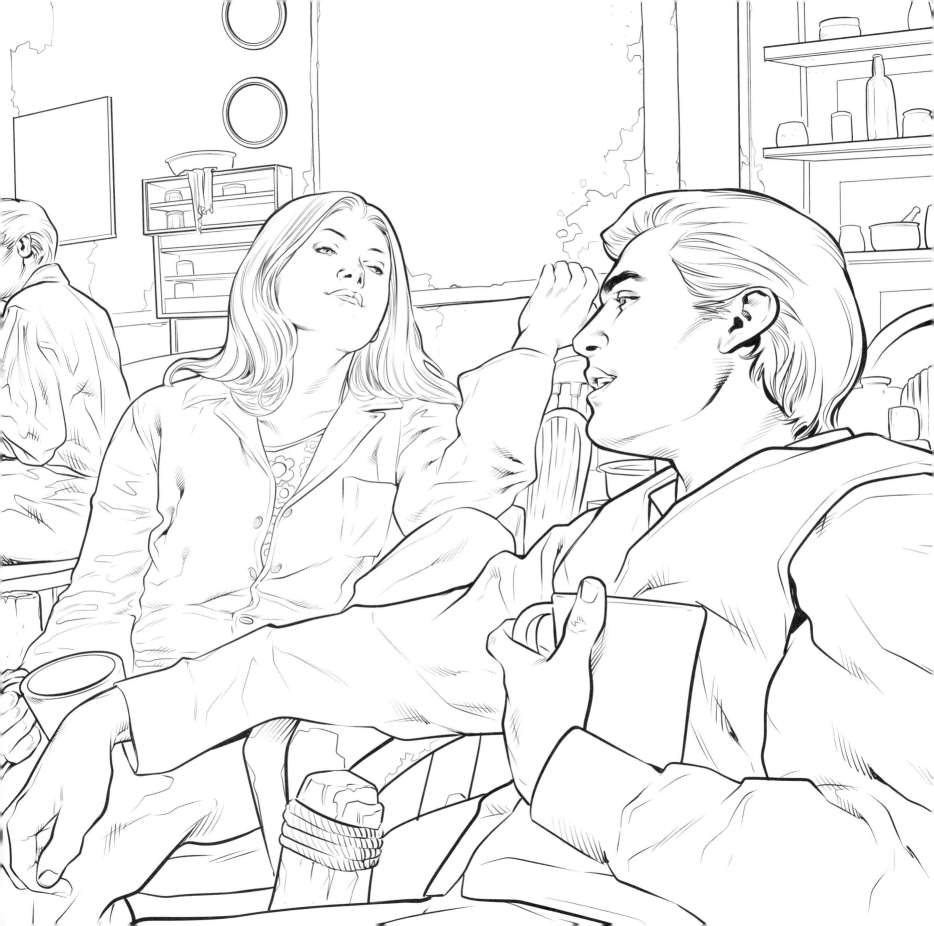

Badger: *There's no deal.*

Zoe: *That ain't fair.*

Badger: *Crime and politics, little girl: the situation is always . . . fluid.*

Jayne: *Only fluid I see here is the puddle of piss refusing to pay us our wage.*
 —"Serenity," Episode 1

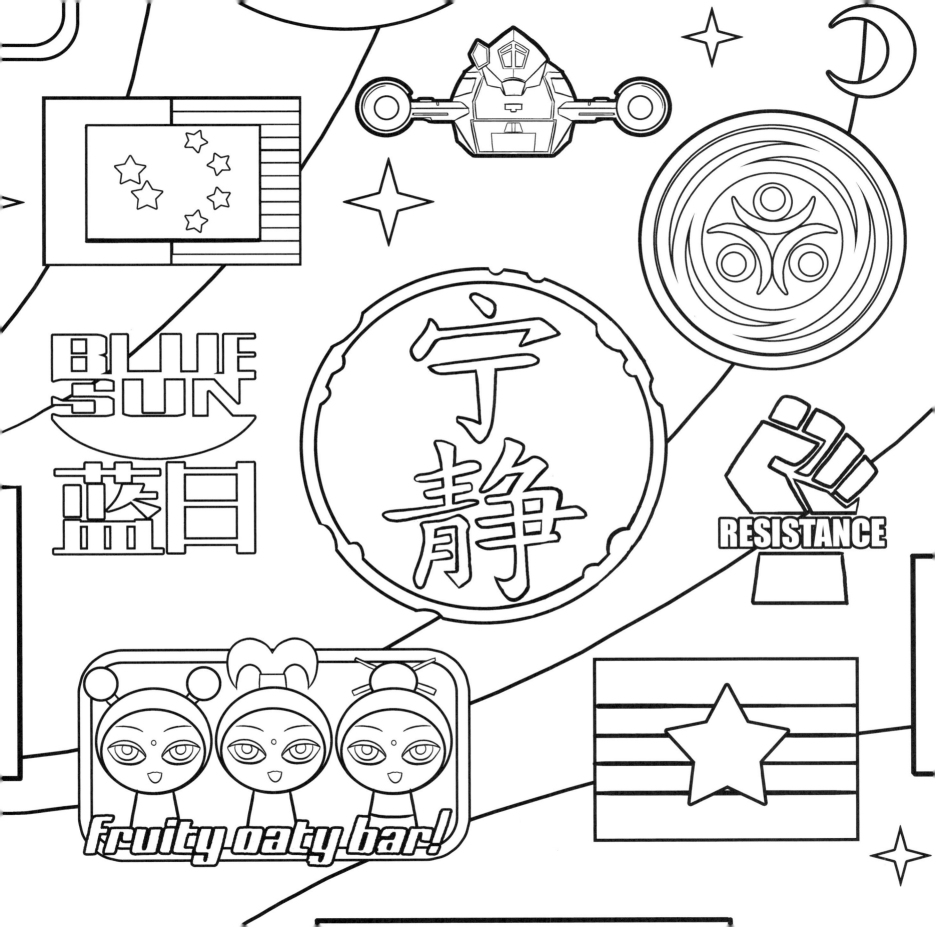

Mal: *As you're all keenly aware, we've run into a bit of a situation. Engine's down, life support's on the fritz, and I got nine people here all wanting to breathe. Truth is, ain't got a whole lot of options at this juncture. So . . . instead of focusing on what we don't got . . . time to talk about what it is we do. And what we got are two shuttles. Short range. Won't go far. But each got heat, and they each got air. Last longer than what's left in* Serenity.

Simon: *Long enough to reach someplace?*

Mal: *No.*

Book: *So . . . where will we go, then?*

Mal: *Far as you can get. We send both shuttles off in opposite directions—betters the chances of someone being seen, maybe getting picked up . . . Shepherd Book, Kaylee, Jayne will ride with Inara in her shuttle. Doc, you and your sis will go with Wash and Zoe seein' as how Zoe still needs some doctorin'.*

Kaylee: *What about you?*

Mal: *Four people per shuttle. That's the arrangement. Evens the odds . . . I'm staying with* Serenity.

—**"Out of Gas,"** Episode 8

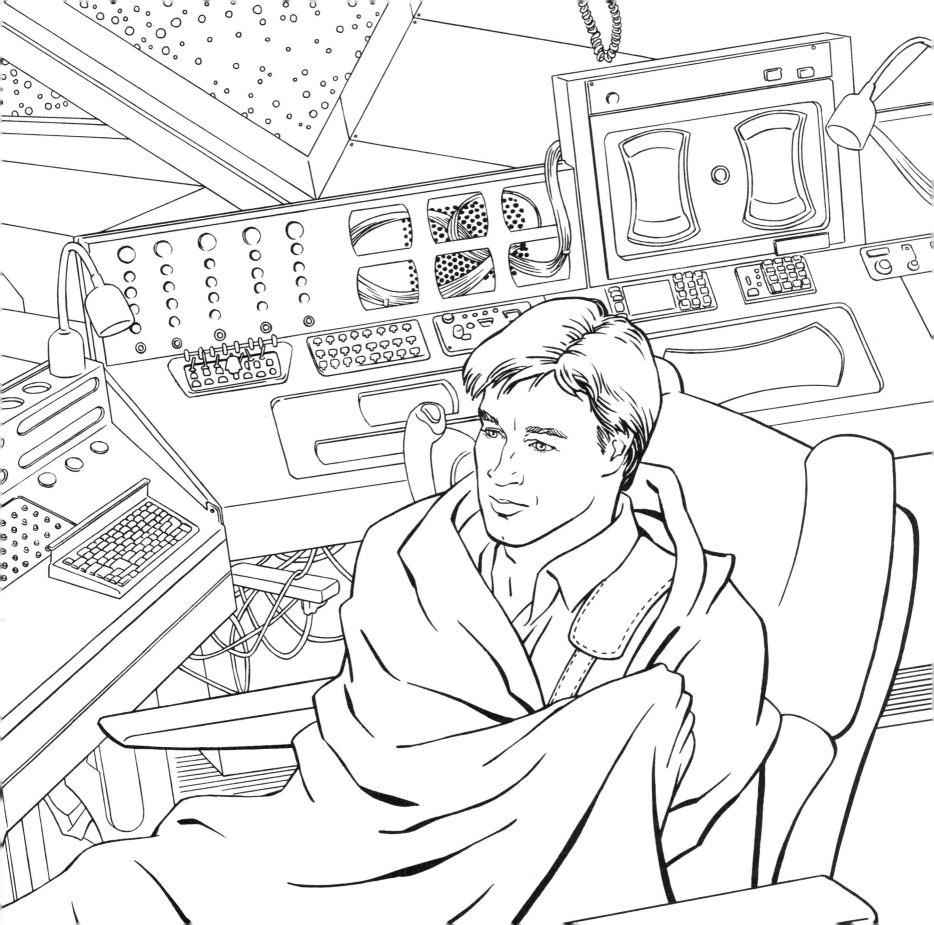

Zoe: *It's a core planet, it's spotless. It's got sensors, and where there ain't sensors, there's feds. All central planets are the same.*

Wash: *Could you please tell my wife the fun she's missing out on?*

Inara: *Ariel's quite a nice place, actually. There are some beautiful museums, not to mention some of the finest restaurants in the core.*

Wash: *But . . . not boring, like she made it sound. There's a . . . Um, ah, um . . .*

Simon: *There's hiking.*

Wash: *Yeah!*

Simon: *And you can go swimming in a bioluminescent lake.*

Zoe: *I don't care if it's got sunsets twenty-four hours a day. I ain't setting foot on that planet.*

Mal: *No one is setting foot on that fancy rock. I don't want anyone leaving the ship. Come to think of it, I don't want anyone looking out the windows or talking aloud. We're here to drop off Inara, that's it.*

Jayne: *What's the point of coming to the core if I can't even step off the boat?*

Mal: *You could have got off with Shepherd Book at the Bathgate Abbey. Could've been meditating on the wonders of your rock garden by now.*

Jayne: *Well, it beats just sittin'.*

Wash: *It* is *just sitting.*

—"Ariel," Episode 9

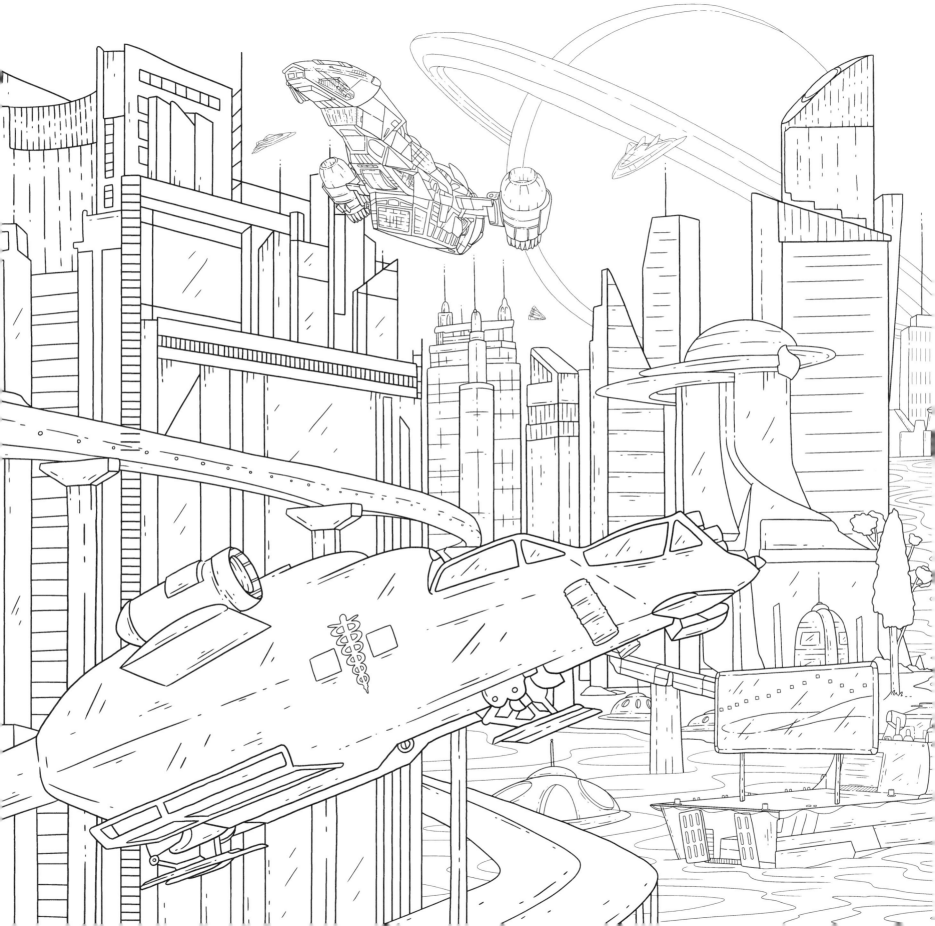

Kaylee: *Zoe, how come you always cut your apples?*

Wash: *You do?*

Kaylee: *Her and Cap'n both. Whenever we get fresh fruit, they never just munch on 'em.*

Zoe: *You know what a griswald is?*

Jayne: *It's a grenade.*

Zoe: *About the size of a battery, responds to pressure. Our platoon was stuck in a trench outside of New Casmir during the winter campaign. More than a week, completely cut off, and the Alliance entrenched not ten yards away. We even got to talkin' to 'em, yelling across insults and jokes and such, 'cause no ammo to speak of, no orders, so what're you gonna do? We mentioned that we were out of rations and ten minutes later, a bunch of apples rained into the trench.*

Wash: *And they grew into a big tree, and they all climbed up the tree to a magical land with unicorns and a harp.*

Kaylee: *Blew off their heads, huh?*

Zoe: *Cap'n said wait, but they were so hungry . . . Don't make much noise, just little pops and there's three guys that kinda just . . . end at the rib cage.*

Wash: *But these apples are healthsome, and good.*

Jayne: *Yeah, grenades cost extra.*

—"War Stories," Episode 10

Inara: *How could he possibly—*

Mal: *Oh, the colonel was* dead *drunk. Three hours pissin' on about the enlisted men. Uh, "they're scum," uh, "they're not fighters," and, uh . . . And then he passed* right out. *Boom.*

Zoe: *We couldn't even move him. So, uh, Tracey just . . . snipped it right off his face.*

Mal: *And you never seen a man more proud of his moustache than Colonel Obrin. I mean, in all my life, I will never love a woman the way this officer loved that lip ferret.*

Zoe: *Big,* walrus-y *thing—all waxed up!*

Inara: *Did he find out?*

Mal: *Oh! Next mornin', he wakes up, it's gone, and he is* furious! *But he can't just say, you know, "Someone stole my moustache!" So he, uh, calls together all the platoons . . .*

Zoe: *We thought he was gonna shoot us!*

Mal: *And, uh . . . Oh, he's eye-ballin' all the men somethin' fierce. Not a word. And he comes up to Tracey, and Tracey's wearing the* gorram *thing on his face!*

Zoe: *He'd glued it on!*

Mal: *He's starin' the old man down wearing his own damn moustache!*
<div align="right">—"The Message," Episode 12</div>

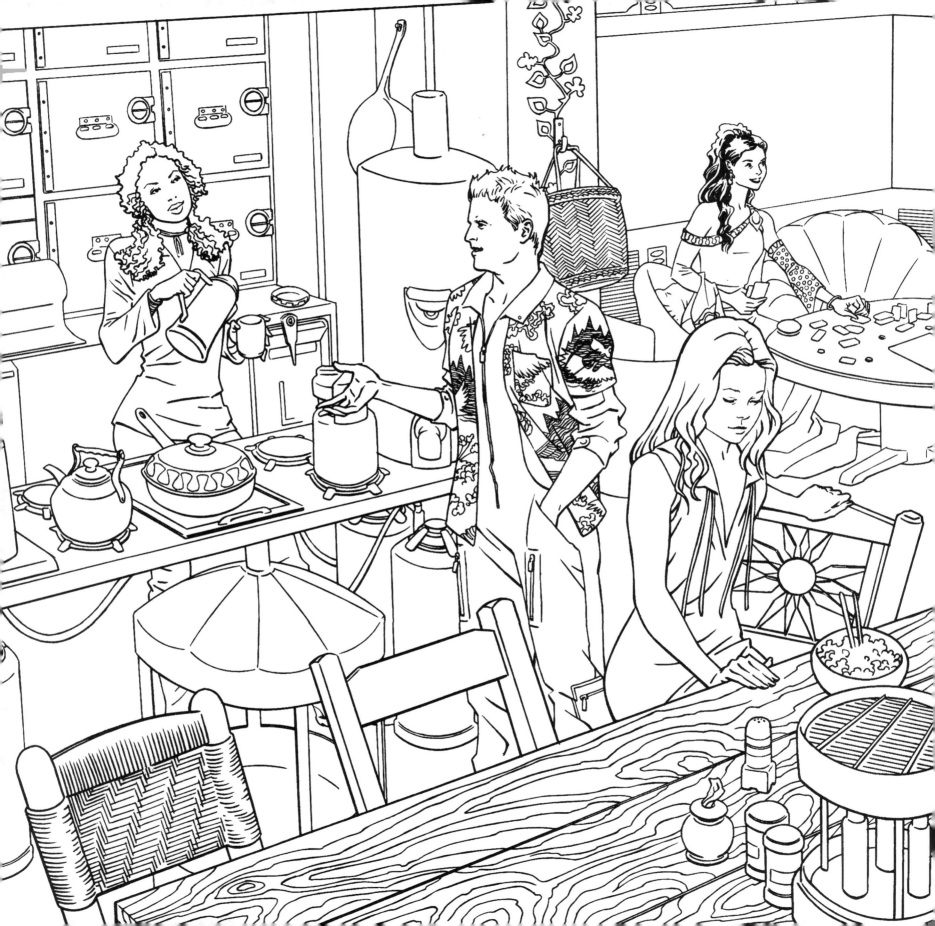

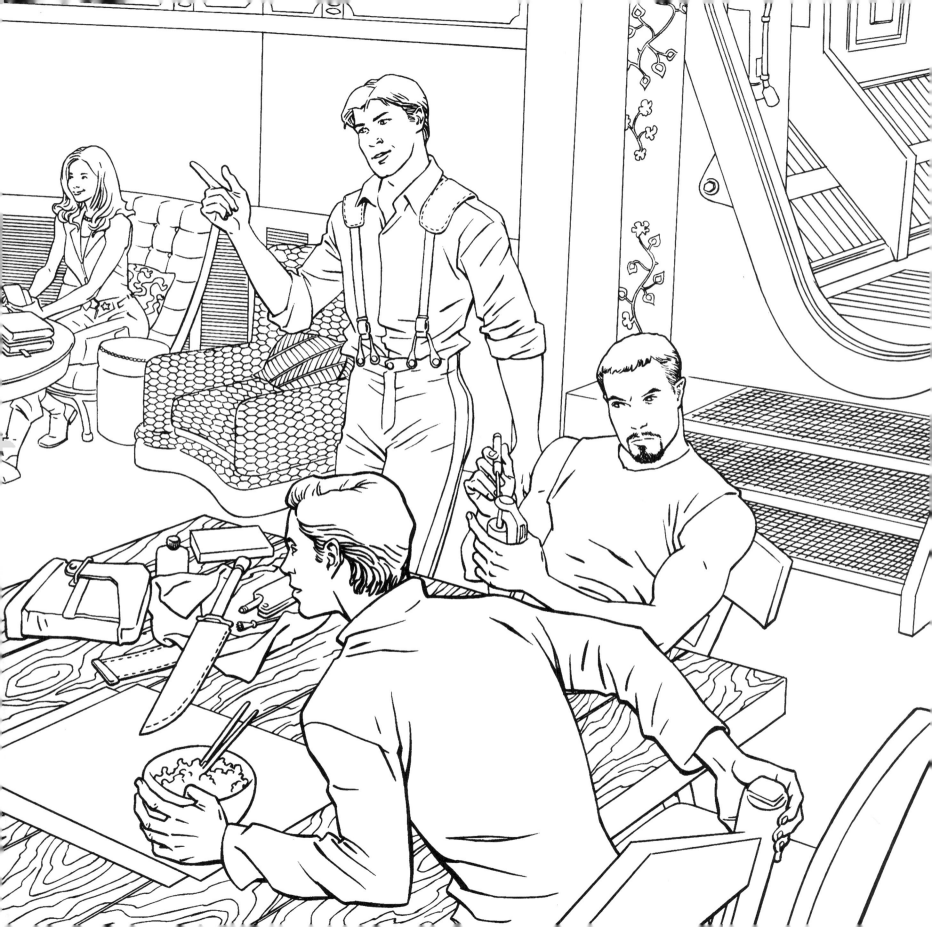

Inara: *You're lost in the woods. We all are. Even the captain. The only difference is he likes it that way.*

Mal: *No, the only difference is the woods are the only place I can see a clear path.*

—"Serenity," Episode 1

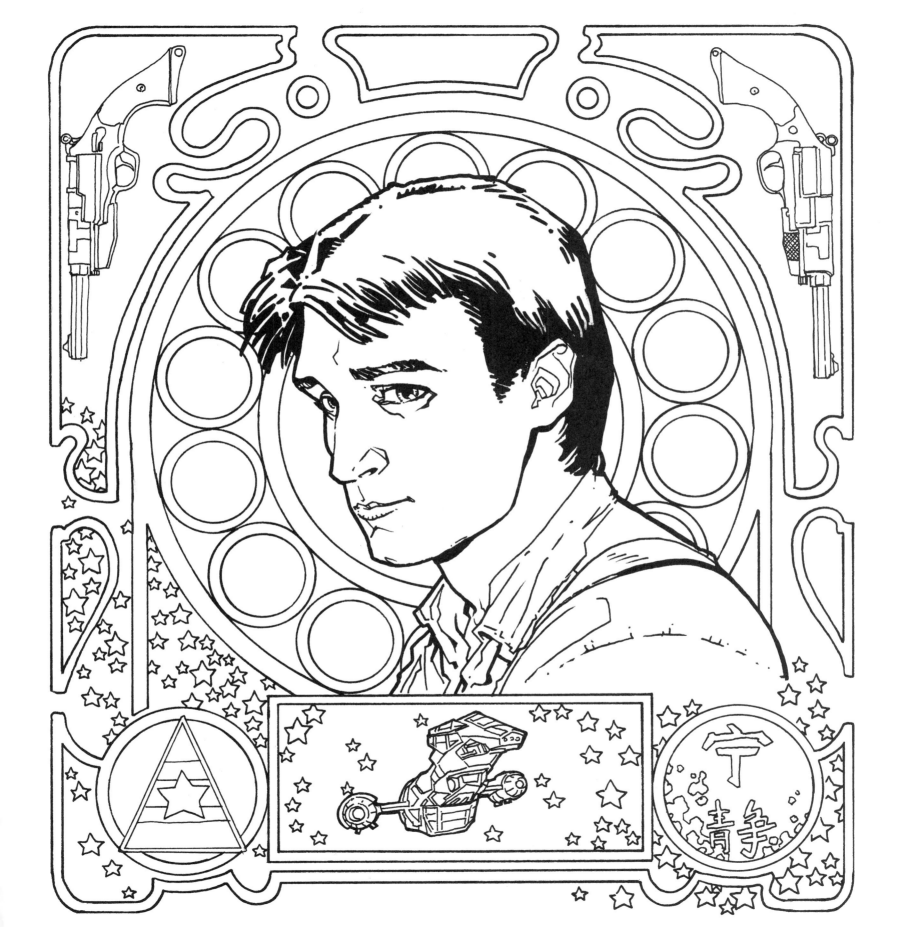

Wash: *I mean, I'm the one that she swore to love, honor, and obey.*

Mal: *Listen, if—She swore to obey?*

Wash: *Well, no . . . not—But that's just my point! You, she obeys! She obeys you. There's obeying going on right under my nose!*

Mal: *Look, Zoe and I have a history—she trusts me.*

Wash: *What's that supposed to mean?*

Mal: *Don't mean a thing, but you're making out like she blindly follows my every word; that ain't true.*

Wash: *Sure it is.*

Mal: *Not so. There's plenty orders of mine that she didn't obey.*

Wash: *Name one!*

Mal: *She married you!*

—"War Stories," Episode 10

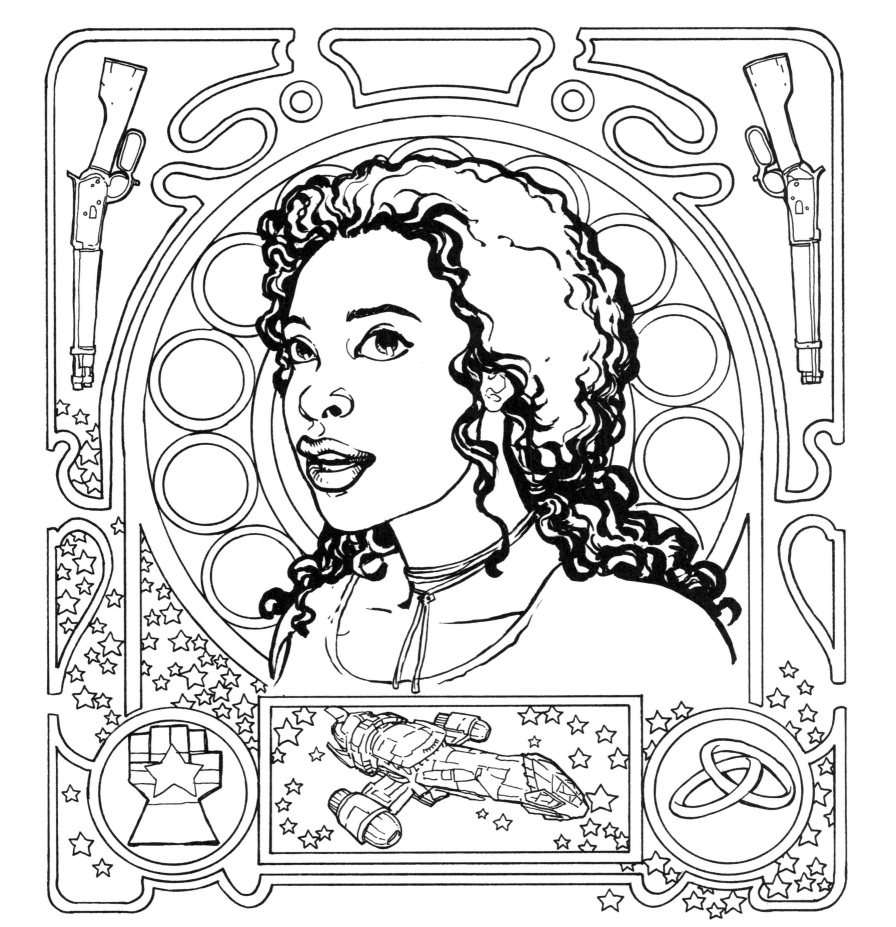

Zoe: *I guess it's a fair bet to say I missed birthday cake.*

Wash: *It's okay, honey. Nobody got to have any. It's still on the floor and some of the walls upstairs, though. If you want I'll run up there and scrape up a piece.*

Zoe: *You'd do that for me?*

Wash: *I'd do anything for you. You know that.*
<div align="right">—"Out of Gas," Episode 8</div>

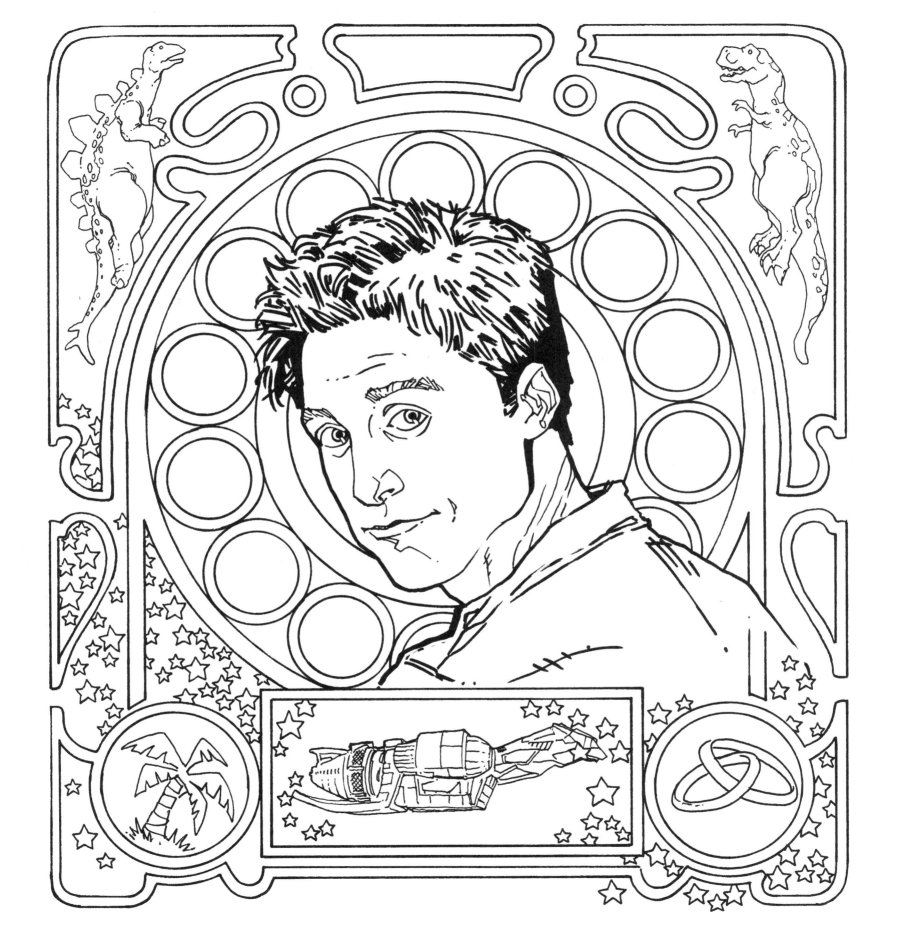

Jayne: *Saint Jayne, got a ring to it!*

Book: *I'm just trying to remember how many miracles you've performed.*

Jayne: *I once hit a guy in the neck from five hundred yards with a bent scope, don't that count upstairs?*

Book: *Oh, it'll be taken into consideration.*

Jayne: *You made that sound kinda ominous.*
—"Objects in Space," Episode 14

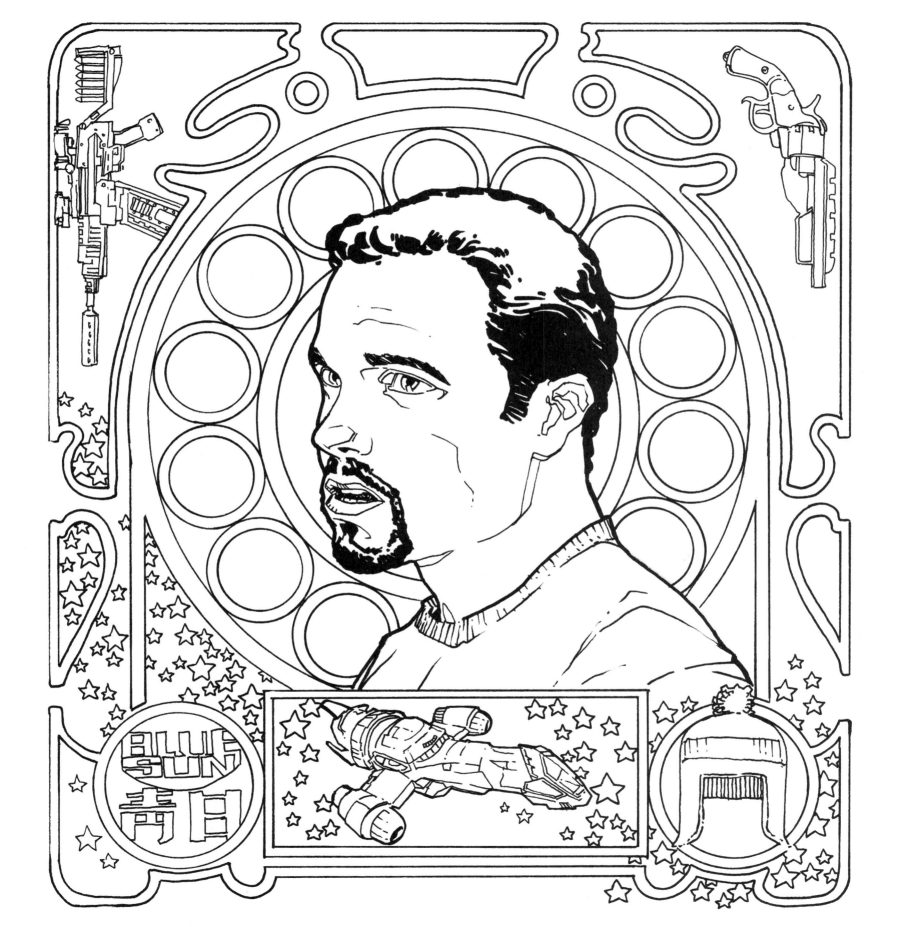

Mal: *You're gonna be fine, Shepherd. Alliance patched you up.*

Book: *Alliance?*

Mal: *Yeah. They let us come, and they let us go. What kind of ident card gets us that kind of reception and send-off?*

Book: *I am a Shepherd. Folks like a man of God.*

Mal: *No, they don't. Men of God make everyone feel guilty and judged. That's not what I saw. You like to tell me what really happened?*

Book: *I surely would. And maybe someday I will.*
<div align="right">—"Safe," Episode 5</div>

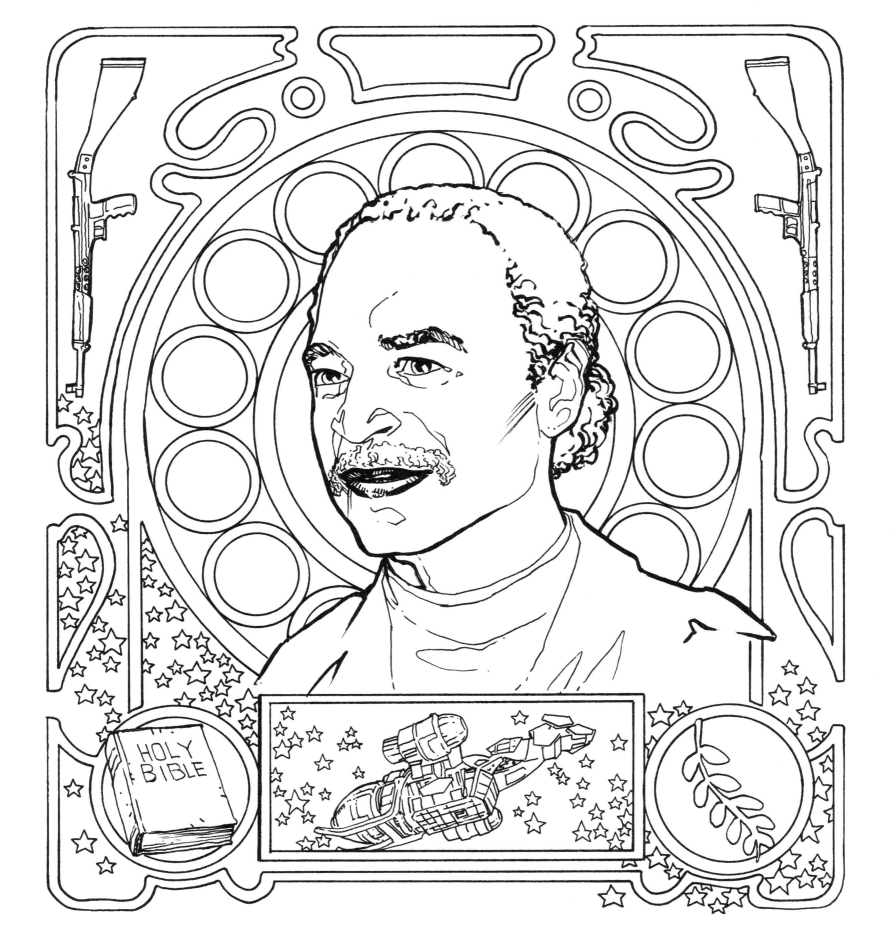

Commander Harken: *I'm just trying to put the pieces together. It's a curiosity: a woman of stature such as yourself falling in with . . . these types.*

Inara: *Not in the least. It's a mutually beneficial business arrangement. I rent the shuttle from Captain Reynolds, which allows me to expand my client base. And the Captain finds that having a Companion on board opens certain doors to him that might otherwise be closed to him.*

—"Bushwhacked," Episode 3

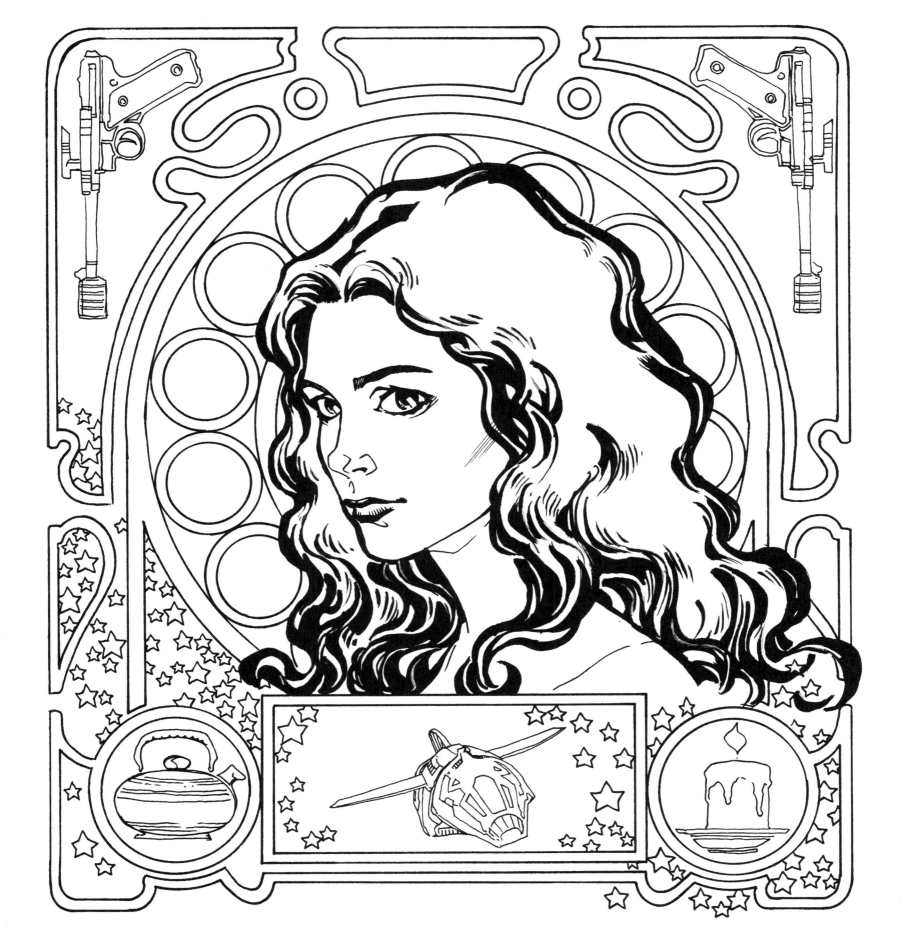

Jayne: *Can you stop her from bein' so cheerful?*

Mal: *I don't believe there is a power in the 'verse that can stop Kaylee from being cheerful. Sometimes you just wanna duct tape her mouth and dump her in the hold for a month.*

Kaylee: *I love my Captain.*

—"Serenity," Episode 1

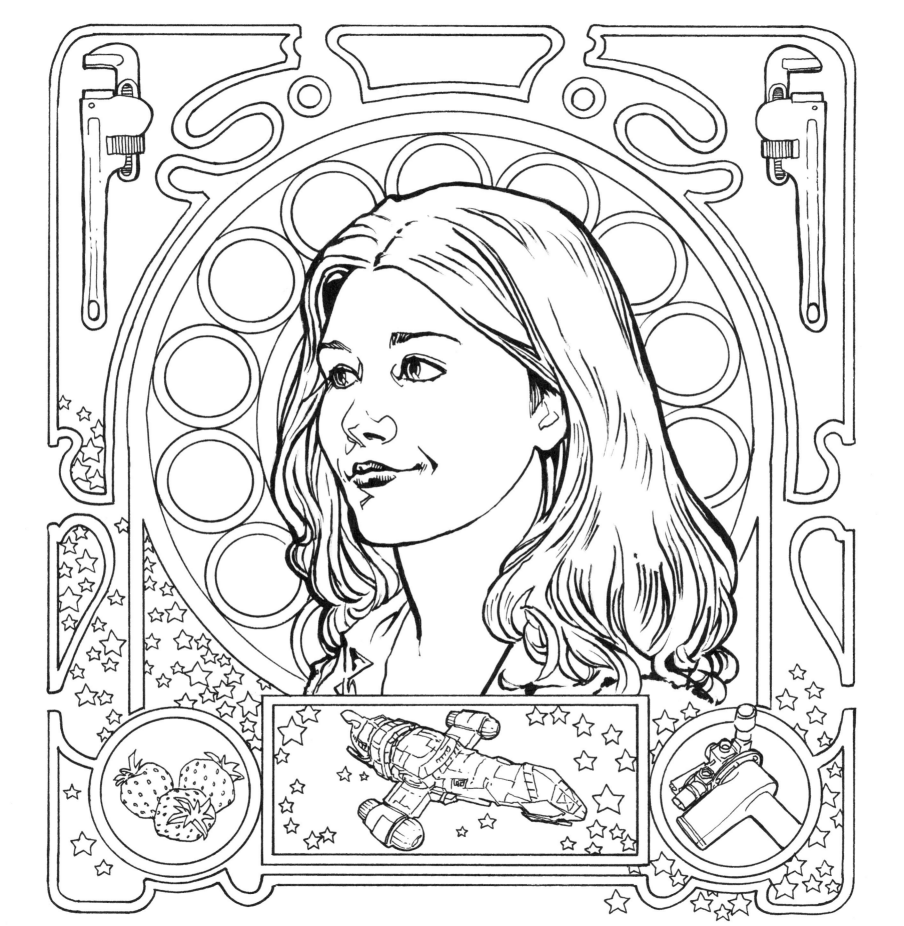

Book: *That young man's very brave.*

Mal: *Yeah. He's my hero.*

Book: *Gave up everything to free his sister from that place. Go from being a doctor on the Central Planets to hiding on the fringes of the system. There's not many would do that.*

Mal: *Suppose not.*

Book: *Not many would take them in, either.*
 —"The Train Job," Episode 2

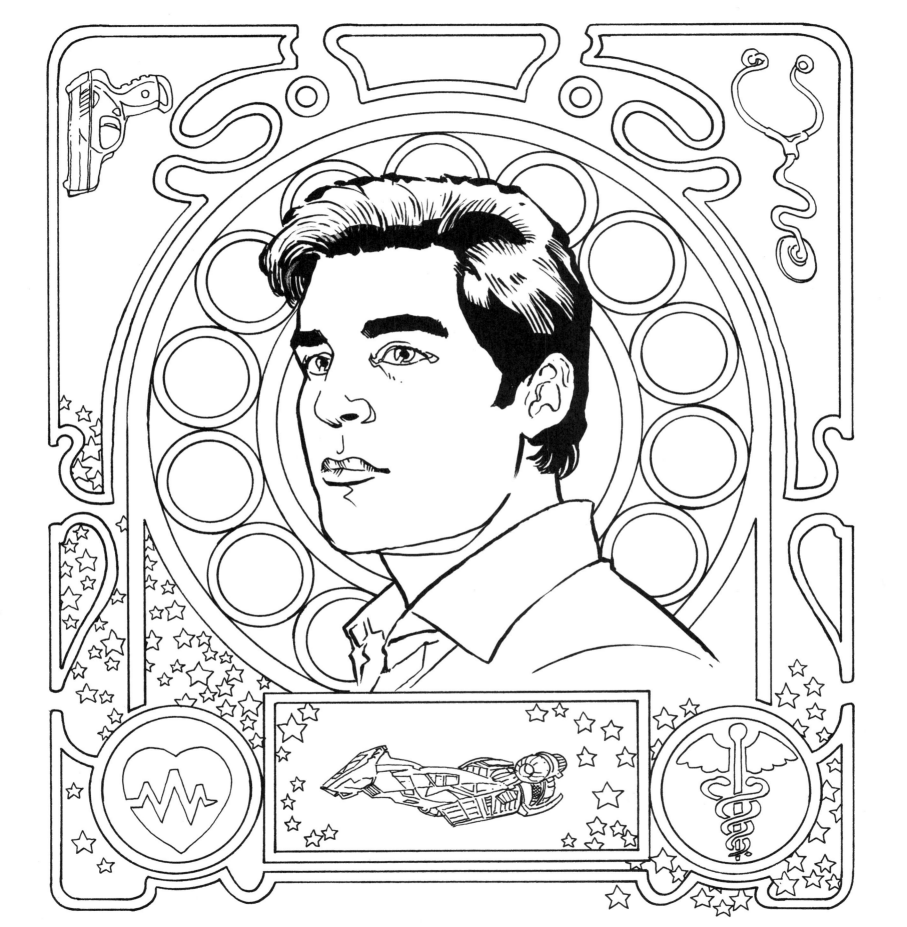

Wash: *Little River gets more colorful by the moment. What'll she do next?*

Zoe: *Either blow us all up or rub soup in our hair. It's a toss-up.*

Wash: *I hope she does the soup thing, it's always a hoot and we don't all die from it.*

—"Objects in Space," Episode 14

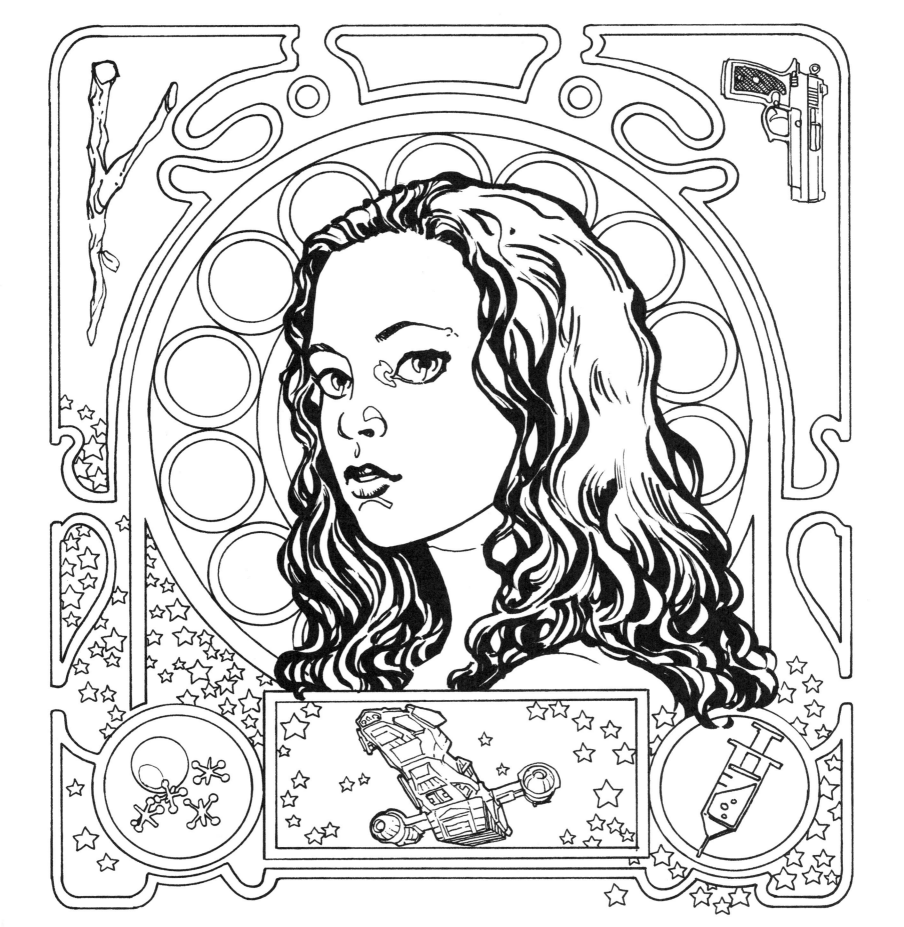

"Ladies and menfolk, we have ourselves a job. Take us out of the world, Wash. Got us some crime to be done."
—Mal, "The Train Job," Episode 2

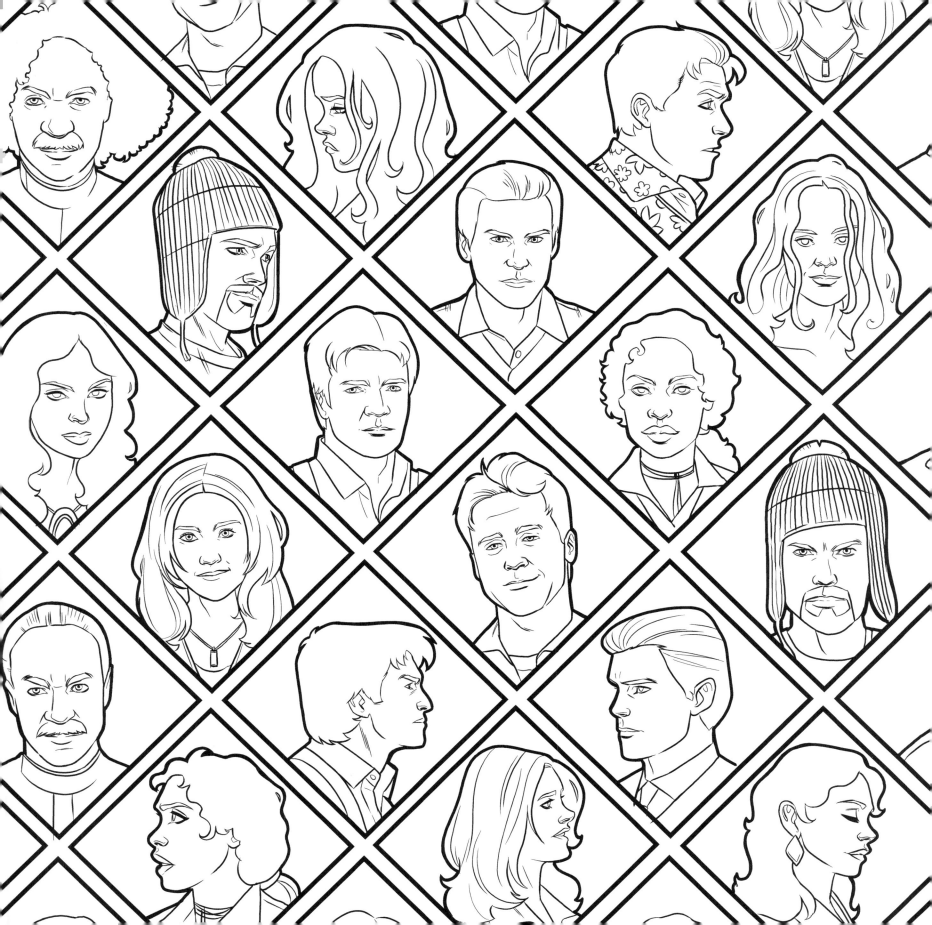

Simon: *Hi. What are you doing?*

River: *Drawing.*

Simon: *That's really good.*

River: *What are you doing?*

Simon: *Oh, I, ah, brought some medicine. Do you remember why we went to the hospital?*

River: *Time to go to sleep again.*

Simon: *No,* mei mei. *It's time to wake up.*

—"Ariel," Episode 9

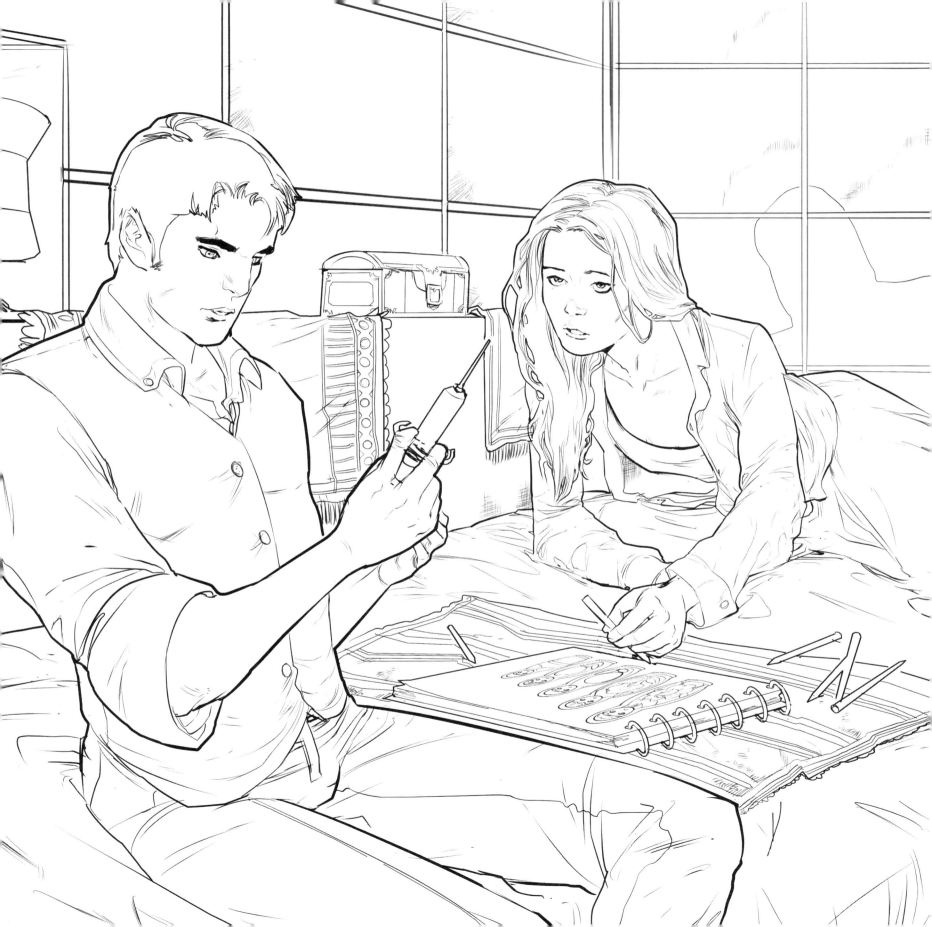

Jayne: *This here's suicide. You do know that, don't you? You really think you can mount a two-man frontal assault on Niska's Skyplex and live?*

Wash: *Technically, it's a one-man/one-woman assault. A unisex. Grenades?*

Zoe: *Oh, yes. Thank you, dear. He won't be expecting it.*

Jayne: *Right. 'Cause they ain't insane.*

Kaylee: *Uh, I just got a wave from Inara. No luck with the Councilor. What are they doin'?*

Jayne: *Fixin' to get themselves killed.*

Zoe: *We're gonna go get the Captain.*

Kaylee: *Oh. Good! Can they do that?*

Jayne: *No.*

Wash: *You know, there's a certain motto. A creed among folks like us. You may have heard it: "Leave no man behind."*

Jayne: *Suicide.*

—"War Stories," Episode 10

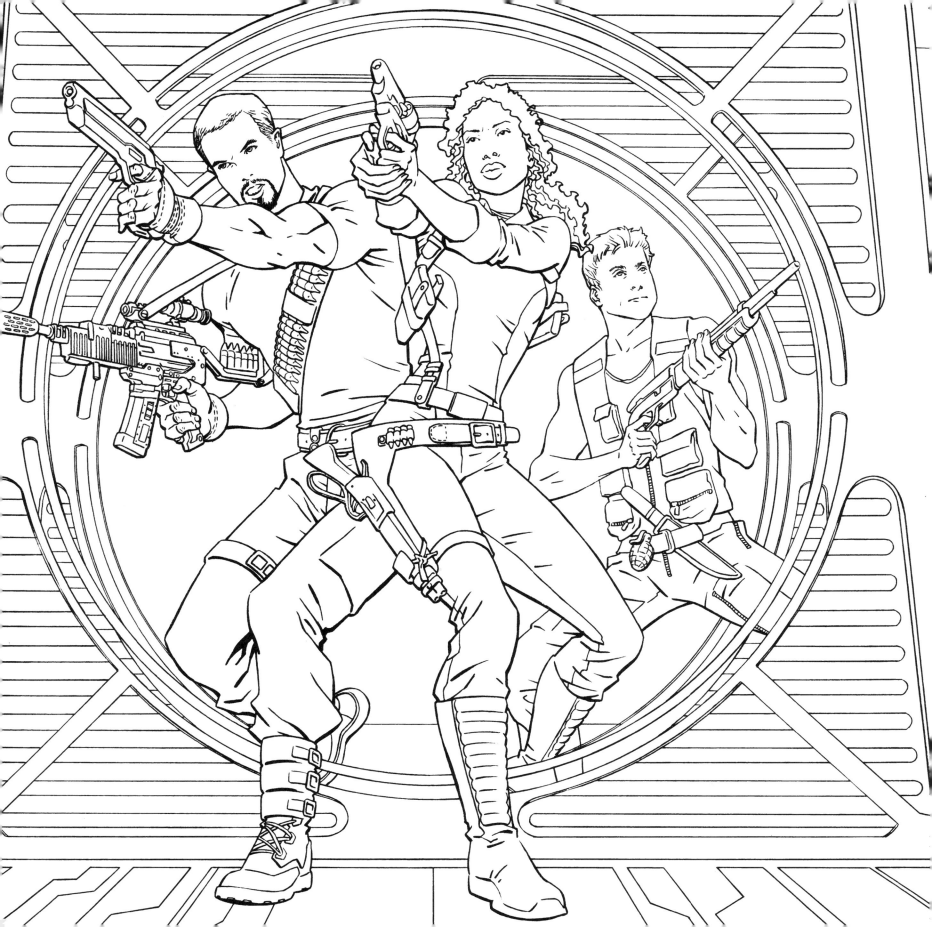

Mal: *Hear you're looking for me?*

Inara: *I was. Care to sit? I was hoping we could talk a little business. Would you like some tea?*

Mal: *Oookay. What's your game?*

Inara: *I offered you tea.*

Mal: *Mm-hm. After inviting me to your shuttle of your own free will which makes two events without precedent which makes me more than a little skittish.*

Inara: *Honestly, Mal, if we can't be civilized—*

Mal: *I'm plenty civilized. You're using wiles on me.*

Inara: *I'm using what?*

Mal: *Your feminine wiles. Your companion training, or some might say uncanny ability to make a man sweaty and/or compliant, of which I've had just about enough of today.*

Inara: *Maybe this isn't the best time.*

Mal: *No, no this is a fine time. You just talk plainly is all.*

—"Trash," Episode 11

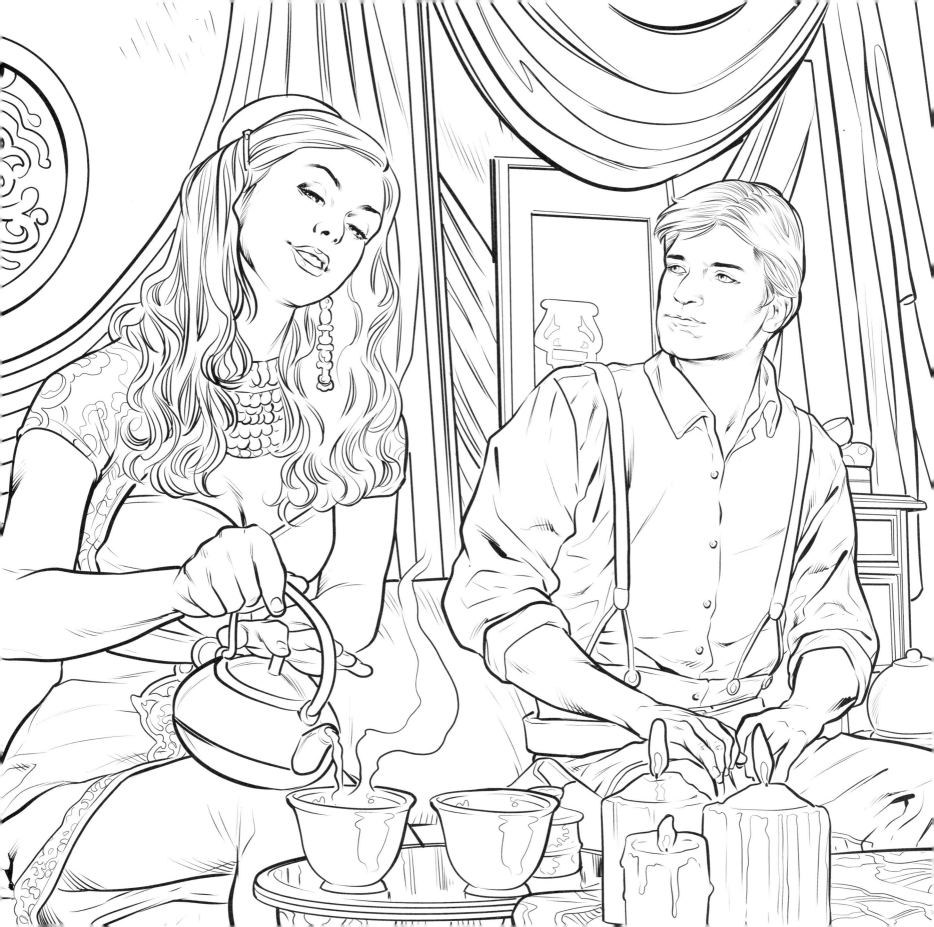

Mal: *Saffron has a notion we can walk right in there, take it off his shelf.*

Wash: *I'm confused.*

Saffron: *You're asking yourself if I've got the security codes, why don't I go in and grab it for myself.*

Wash: *No, actually, I was wondering . . . What's she doing on the ship?! Didn't she try to kill us?!*

Saffron: *Please, nobody died last time.*

Wash: *We're in space, how'd she get here?*

Mal: *She hitched.*

Wash: *I don't recall pulling over!*

Mal: *Point is, this ain't no wobbly-headed doll caper. This here's history.*

Jayne: *Okay, I've got a question. If she's got security codes, why don't she just walk in and grab it herself?*

Saffron: *Good point.*

—"Trash," Episode 11

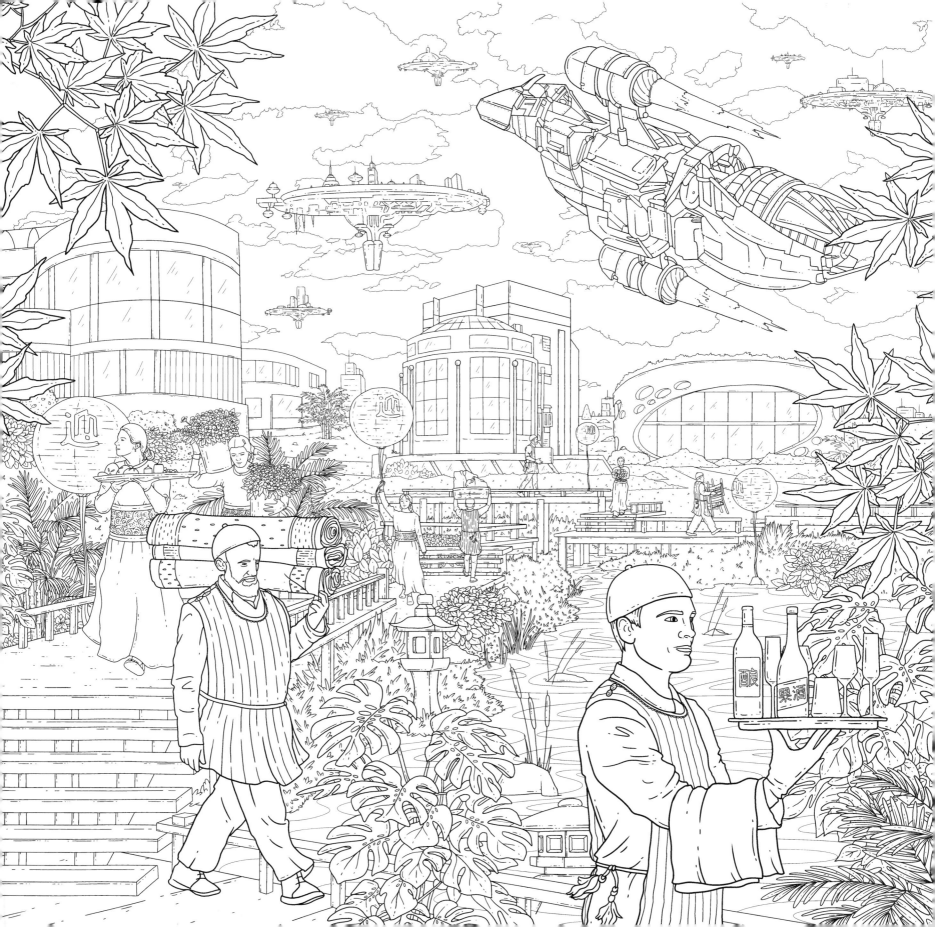

Simon: *How much did they offer you to sell out me and River on Ariel?*

Jayne: *Das crazy talk.*

Simon: *Then let's talk crazy. How much?*

Jayne: *Anybody there? . . . Anybody else?*

Simon: *No matter what you do, or say or plot, no matter how you come down on us . . . I will never, ever harm you. You're on this table, you're safe. 'Cause I'm your medic, and however little we may like or trust each other, we're on the same crew. Got the same troubles, same enemies, and more than enough of both. Now, we could circle each other and growl, sleep with one eye open, but that thought wearies me. I don't care what you've done, I don't know what you're planning on doing, but I'm trusting you. I think you should do the same. 'Cause I don't see this working any other way.*

River: *Also . . . I can kill you with my brain.*

—"Trash," Episode 11

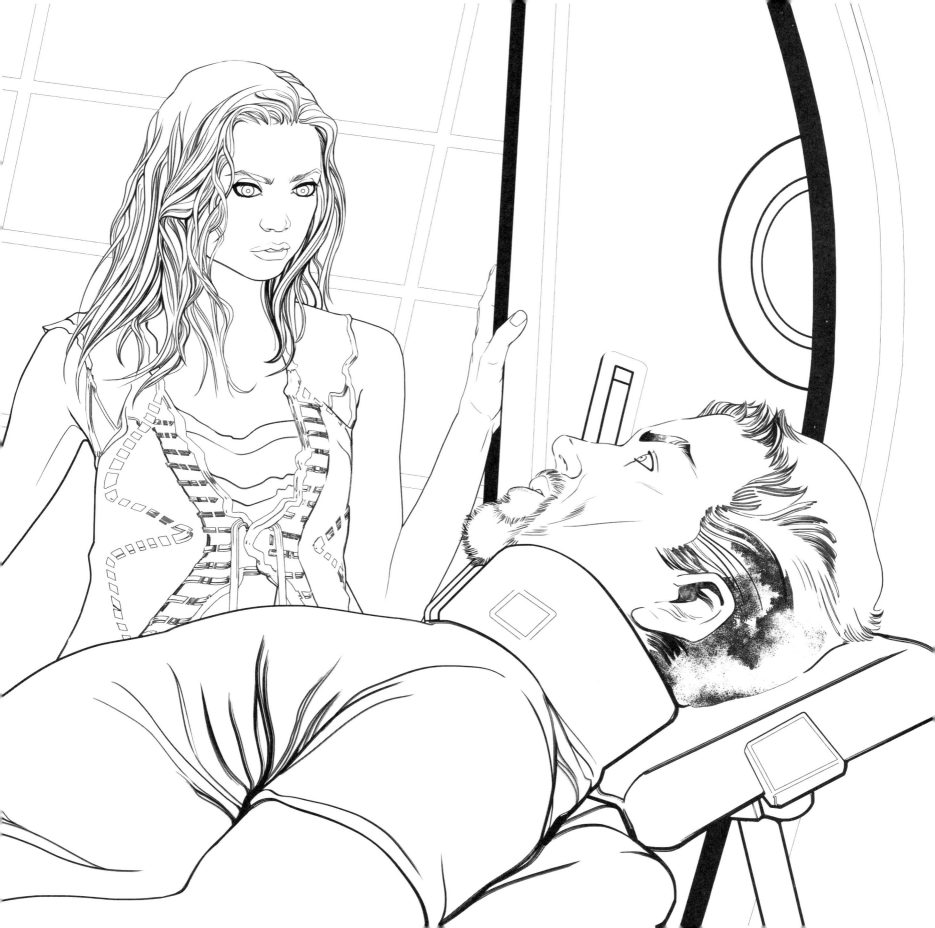

Tracey: *Anything interesting out there? If you don't mind my asking?*

Zoe: *'Bout thirty troops behind those buildings, mortars, no rollers yet. I expect they plan to peck at us for a spell before they charge. I had two scouts sniffin', but I took 'em down.*

Tracey: *Wow, I didn't hear a single thing.*

Zoe: *First rule of battle, little one, don't ever let them know where you are.*

Mal: Woo-hoo! I'm right here! I'm right here! You want some of this? Yeah, you do! Come on! Come on! Woo-hoo!

Zoe: *'Course there are other schools of thought.*
<div align="right">—"The Message," Episode 12</div>

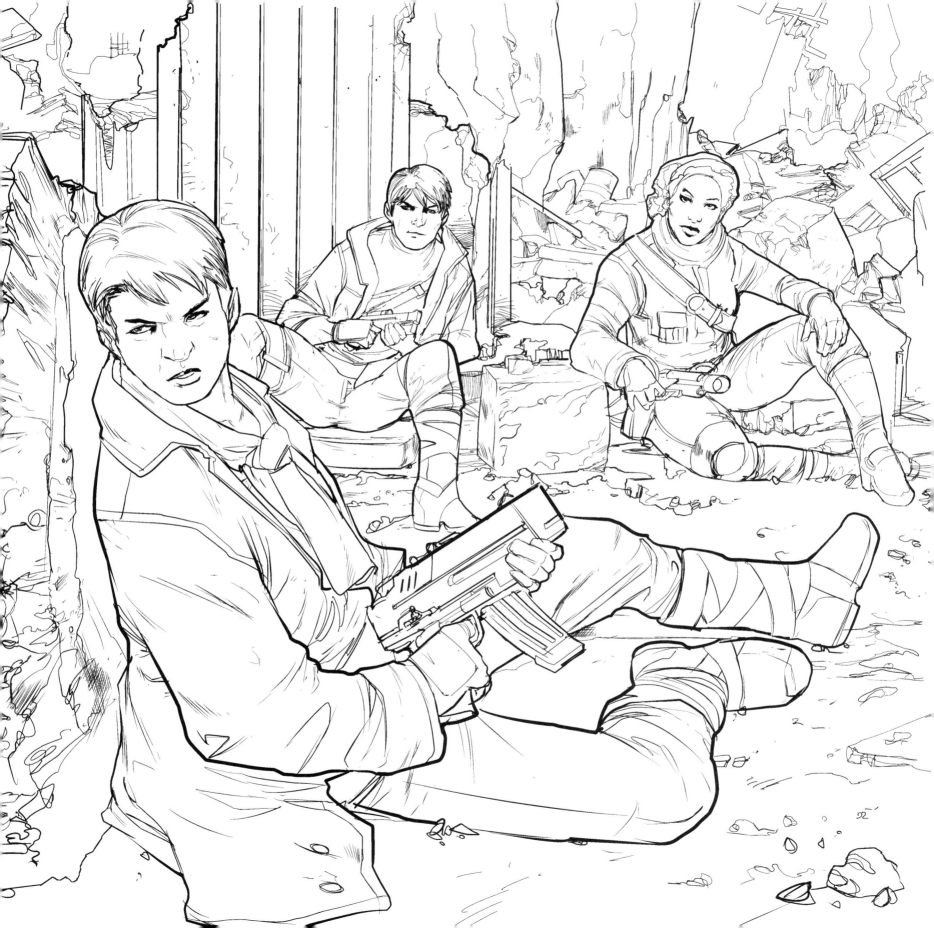

Nandi: *Captain Reynolds, it took me years to cut this piece of territory out of other men's hands, to build this business up from nothing.*

Mal: *Nandi . . .*

Nandi: *It's who I am, and it's my home. I'm not going anywhere . . .*

Mal: *Well, lady, I must say—you're my kinda stupid.*
—"Heart of Gold," Episode 13

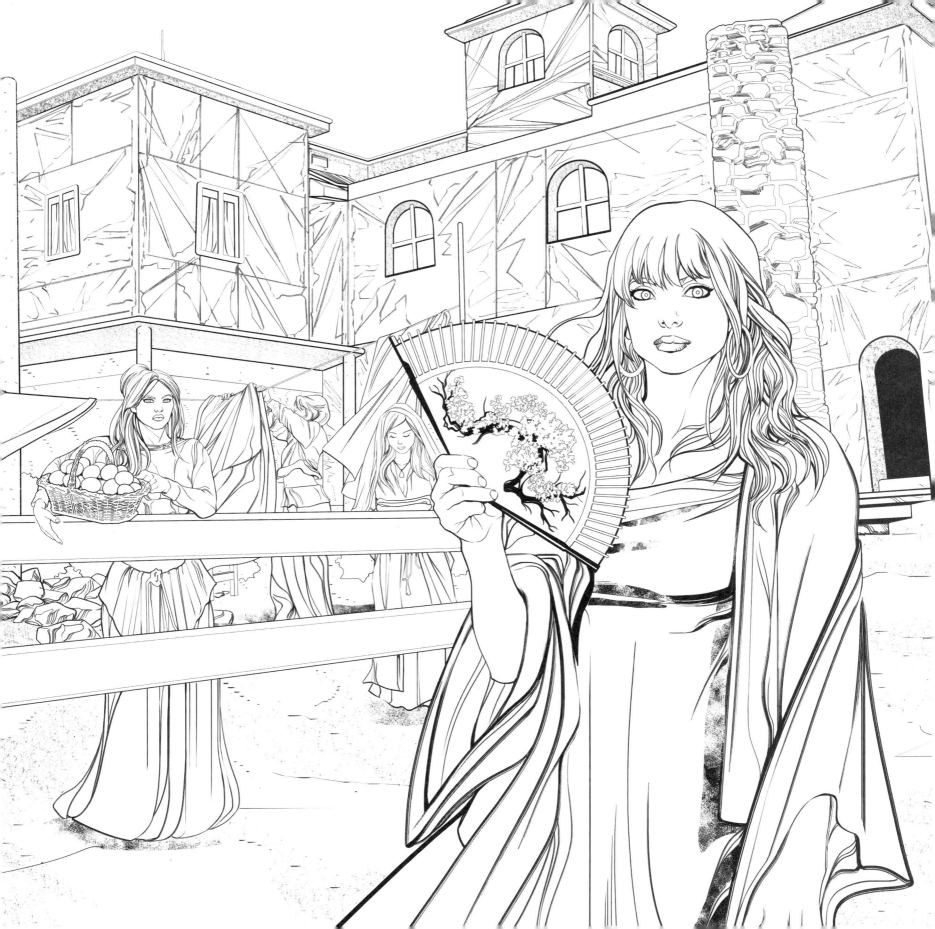

"No one's killin' any folk today, on account o' we got a very tight schedule."

—Mal, "Trash," Episode 11

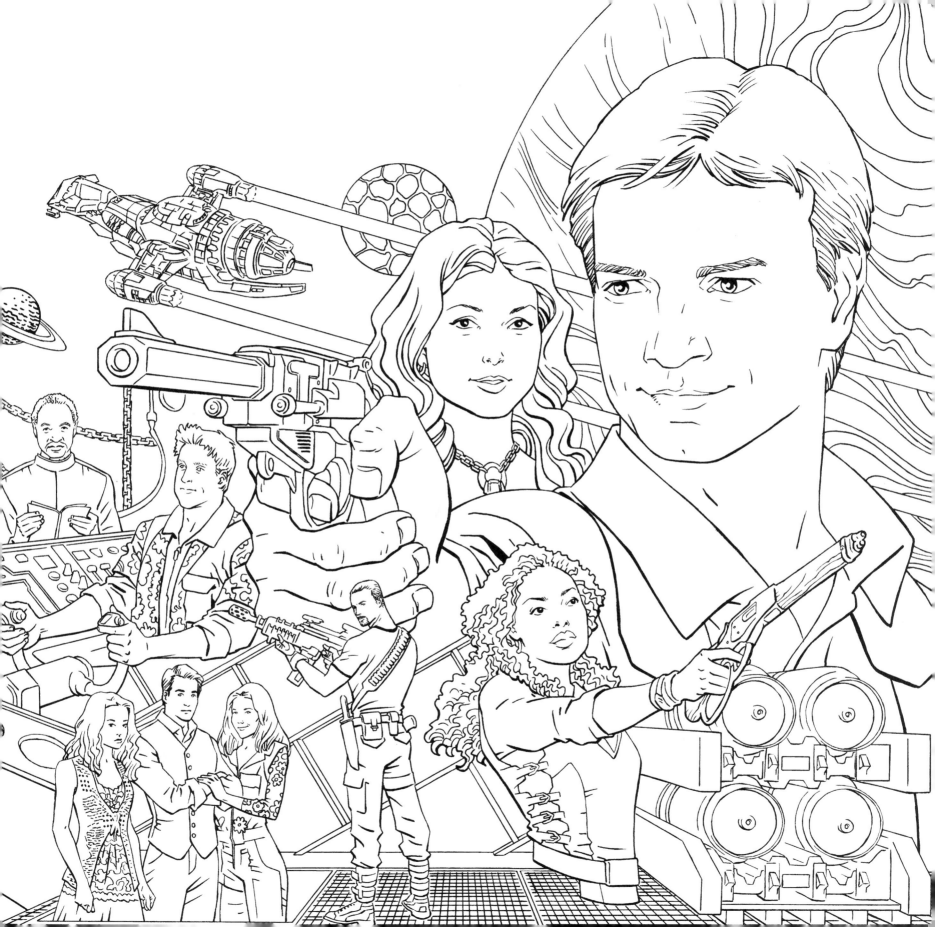

Zoe: *It's a piece of junk.*

Mal: *Junk? Okay. She won't be winning any beauty contests anytime soon. But she is solid. Ship like this, be with ya 'til the day you die.*

Zoe: *'Cause it's a deathtrap.*

Mal: *That's not . . . You are very much lacking in imagination.*

Zoe: *I imagine that's so, sir.*

Mal: *C'mon. You ain't even seen most of it. I'll show you the rest. And try to see past what she is, and on to what she can be.*

Zoe: *What's that, sir?*

Mal: *Freedom, is what.*

—"Out of Gas," Episode 8

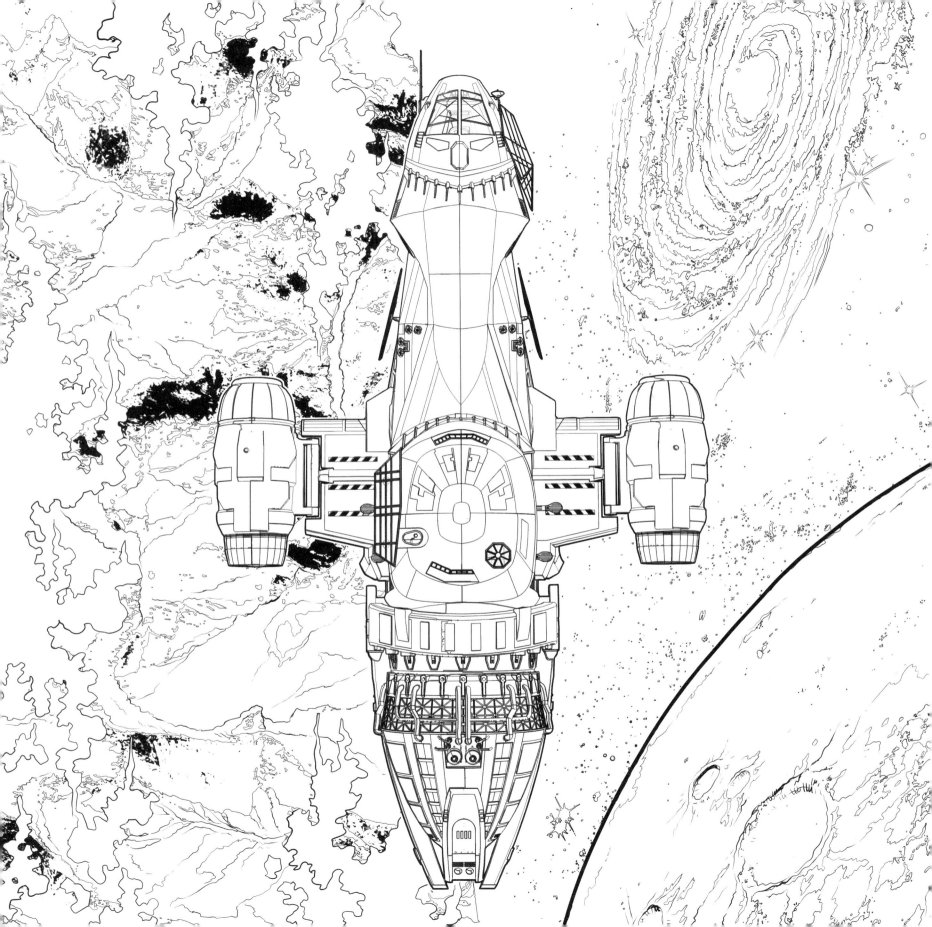

ABOUT THE ILLUSTRATORS

STEPHEN BYRNE (pages 9, 29, 37, 47, 75)
Stephen Byrne was born in Dublin, Ireland. At age twelve he proclaimed to the world that he would be a comic artist when he grew up. He studied at the Irish School of Animation and has worked in movies, TV, video games, and comics. He now lives in London, where his best friend is his digital drawing stylus.

PABLO CHURIN (pages 17, 20-21, 25, 39, 41, 49, 54-55, 79, 91)
Pablo Churin was born in Argentina. After beginning his career as an artist for fanzines, his comics work began with a horror miniseries for Studio 407 called Hybrid. *Some of Pablo's professional work includes* Agon *for Zenescope Entertainment,* El General San Martín *for Ovni Press,* Thief: Tales from the City *for Dark Horse Comics,* God Is Dead *for Avatar Press, and several web comics for MTJ Publishing.*

WILL CONRAD (pages 12-13, 45, 81, 93)
Brazilian artist Will Conrad has been working in comics since 2001. His collaborations include X-Men, Avengers, Wolverine, Outsiders, Green Lantern, Action Comics, and Cyborg, among many others. His first job was inking Joss Whedon's Buffy the Vampire Slayer. *He later came back to Dark Horse's Whedonverse in* Serenity: Those Left Behind, Serenity: Better Days, *and* Angel & Faith.

EDUARDO FRANCISCO (pages 7, 27, 31, 85, 89)
Brazilian author and illustrator Eduardo Francisco had his first professional work published by a RPG magazine at eighteen years old. Eduardo's work has been published in the Middle East, Brazil, England, and the United States, and includes titles like Executive Assistant: Iris!, World of Flashpoint, Adventures of Superman, Ame-Comi Girls, Infinite Crisis, Turok: Son of Stone, Conan: The Avenger, EVE: Valkyrie, SMITE, *and* Aliens: Defiance. *Eduardo has also worked providing illustrations and concept art for TV and games studios.*

JUAN FRIGERI (cover, pages 5, 23, 43, 77, 87)
Artist Juan Frigeri was born in 1983 in Rosario, Argentina. He began his comic career in 1998 and has contributed to such popular works as Star Wars: Darth Maul—Son of Dathomir *from Dark Horse Comics, and* God is Dead *from Avatar Press.*

GEORGES JEANTY (pages 57, 59, 61, 63, 65, 67, 69, 71, 73)
Serenity *and* Buffy the Vampire Slayer *artist Georges Jeanty studied fine arts at Miami Dade College. He worked for DC Comics on titles such as* Green Lantern, Superboy, *and* Superman. *The year 2006 brought Georges the critically acclaimed comics miniseries* The American Way, *written by John Ridley and released through WildStorm. Georges was handpicked by Joss Whedon to become the artist on* Buffy Season 8, *the Eisner Award winner for Best New Series in 2008. He continued as the regular series artist for* Buffy the Vampire Slayer *Season 9 and recently was the artist for the* Serenity: Firefly Class 03-K64 *series,* Leaves on the Wind *and* No Power in the 'Verse, *before returning to* Buffy the Vampire Slayer *Season 11.*

TAYLOR ROSE (pages 15, 33, 35, 51, 83)
Taylor Rose lives, works, and plays in Bend, Oregon as a freelance illustrator and designer. When she is not making art you can find her traveling by snowboard, bicycle, and stand up paddle board. She loves fly fishing and has a somewhat healthy obsession with cartoons, hobbits, Buffy the Vampire Slayer, *and owls. Taylor's art has also recently been featured in the* Buffy the Vampire Slayer: Big Bads & Monsters *Adult Coloring Book.*

LOOKING FOR MORE SERENITY?

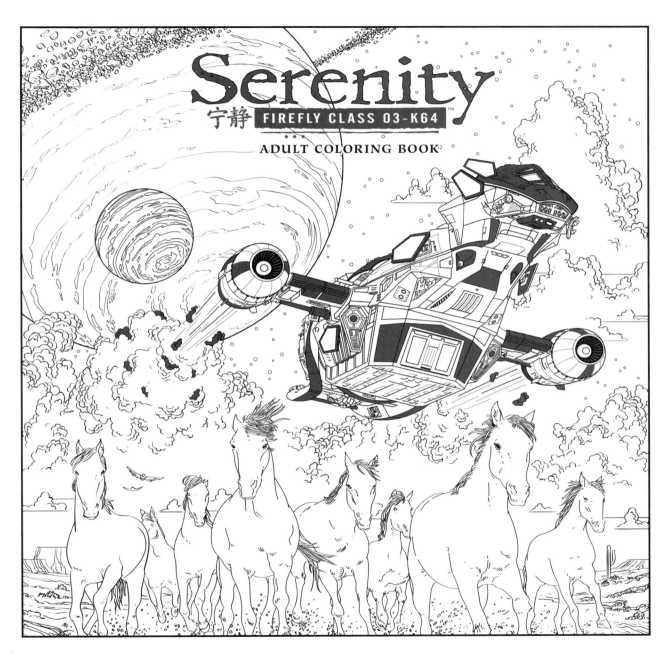

Serenity Adult Coloring Book

Join the space pirate crew of *Serenity* on adventures through the 'verse where you can relive your favorite moments and celebrate the world of *Firefly*, Joss Whedon's cult-hit television series. This coloring book is filled with forty-five black-and-white, detailed, and completely original illustrations for you to color, along with classic and endearing quotes from Malcolm Reynolds and the series' entire cast of core characters.

ISBN 978-1-50670-253-7
$14.99

MORE FROM JOSS WHEDON AND DARK HORSE BOOKS!

SERENITY VOLUME 1: THOSE LEFT BEHIND
Joss Whedon, Brett Matthews, and Will Conrad
ISBN 978-1-59307-449-4 | $9.99

SERENITY VOLUME 2: BETTER DAYS
Joss Whedon, Brett Matthews, and Will Conrad
ISBN 978-1-59582-162-1 | $9.99

SERENITY VOLUME 3: THE SHEPHERD'S TALE
Joss Whedon, Zack Whedon, and Chris Samnee
ISBN 978-1-59582-561-2 | $14.99

SERENITY VOLUME 4: LEAVES ON THE WIND
Zack Whedon, Georges Jeanty, and Karl Story
978-1-61655-489-7 | $19.99

DR. HORRIBLE AND OTHER HORRIBLE STORIES
Joss Whedon, Zack Whedon, and Joëlle Jones
ISBN 978-1-59582-577-3 | $9.99

DOLLHOUSE: EPITAPHS
Andrew Chambliss, Jed Whedon, Maurissa Tancharoen, and Cliff Richards
ISBN 978-1-59582-863-7 | $18.99

BUFFY THE VAMPIRE SLAYER: THE HIGH SCHOOL YEARS—FREAKS & GEEKS
Faith Erin Hicks and Yishan Li
ISBN 978-1-61655-667-9 | $10.99

BUFFY THE VAMPIRE SLAYER SEASON 8 LIBRARY EDITION
VOLUME 1
ISBN 978-1-59582-888-0 | $29.99

VOLUME 2
ISBN 978-1-59582-935-1 | $29.99

VOLUME 3
ISBN 978-1-59582-978-8 | $29.99

VOLUME 4
ISBN 978-1-61655-127-8 | $29.99

BUFFY THE VAMPIRE SLAYER SEASON 9 LIBRARY EDITION
VOLUME 1
ISBN 978-1-61655-715-7 | $29.99

VOLUME 2
ISBN 978-1-61655-716-4 | $29.99

VOLUME 3
ISBN 978-1-61655-717-1 | $29.99

BUFFY THE VAMPIRE SLAYER SEASON 10
VOLUME 1: NEW RULES
Christos Gage, Rebekah Isaacs, Nicholas Brendon, and others
ISBN 978-1-61655-490-3 | $18.99

VOLUME 2: I WISH
Christos Gage, Karl Moline, Nicholas Brendon, and others
ISBN 978-1-61655-600-6 | $18.99

VOLUME 3: LOVE DARES YOU
Christos Gage, Rebekah Isaacs, Nicholas Brendon, and Megan Levens
ISBN 978-1-61655-758-4 | $18.99

VOLUME 4: OLD DEMONS
Christos Gage and Rebekah Isaacs
ISBN 978-1-61655-802-4 | $18.99

VOLUME 5: PIECES ON THE GROUND
Christos Gage, Megan Levens, and Rebekah Isaacs
ISBN 978-1-61655-944-1 | $18.99

BUFFY THE VAMPIRE SLAYER: TALES
Joss Whedon, Amber Benson, Cameron Stewart, and others
ISBN 978-1-59582-644-2 | $29.99

BUFFY THE VAMPIRE SLAYER: PANEL TO PANEL—SEASONS 8 & 9
978-1-61655-743-0 | $24.99

ANGEL & FAITH SEASON 9 LIBRARY EDITION
VOLUME 1
ISBN 978-1-61655-712-6 | $29.99

VOLUME 2
ISBN 978-1-61655-713-3 | $29.99

VOLUME 3
ISBN 978-1-61655-714-0 | $29.99

ANGEL & FAITH SEASON 10
VOLUME 1: WHERE THE RIVER MEETS THE SEA
Victor Gischler, Will Conrad, Derlis Santacruz, and others
ISBN 978-1-61655-503-0 | $18.99

VOLUME 2: LOST AND FOUND
Victor Gischler and Will Conrad
ISBN 978-1-61655-601-3 | $18.99

VOLUME 3: UNITED
Victor Gischler and Will Conrad
ISBN 978-1-61655-766-9 | $18.99

VOLUME 4: A LITTLE MORE THAN KIN
Victor Gischler, Cliff Richards, and Will Conrad
ISBN 978-1-61655-890-1 | $18.99

VOLUME 5: A TALE OF TWO FAMILIES
Victor Gischler and Will Conrad
ISBN 978-1-61655-965-6 | $18.99

AVAILABLE AT YOUR LOCAL COMICS SHOP OR BOOKSTORE
TO FIND A COMICS SHOP IN YOUR AREA, CALL 1-888-266-4226

For more information or to order direct: **On the web**: DarkHorse.com | **Email**: mailorder@darkhorse.com **Phone**: 1-800-862-0052 | Mon.–Fri. 9 AM to 5 PM Pacific Time.